WATERCOLOUR
fast & loose

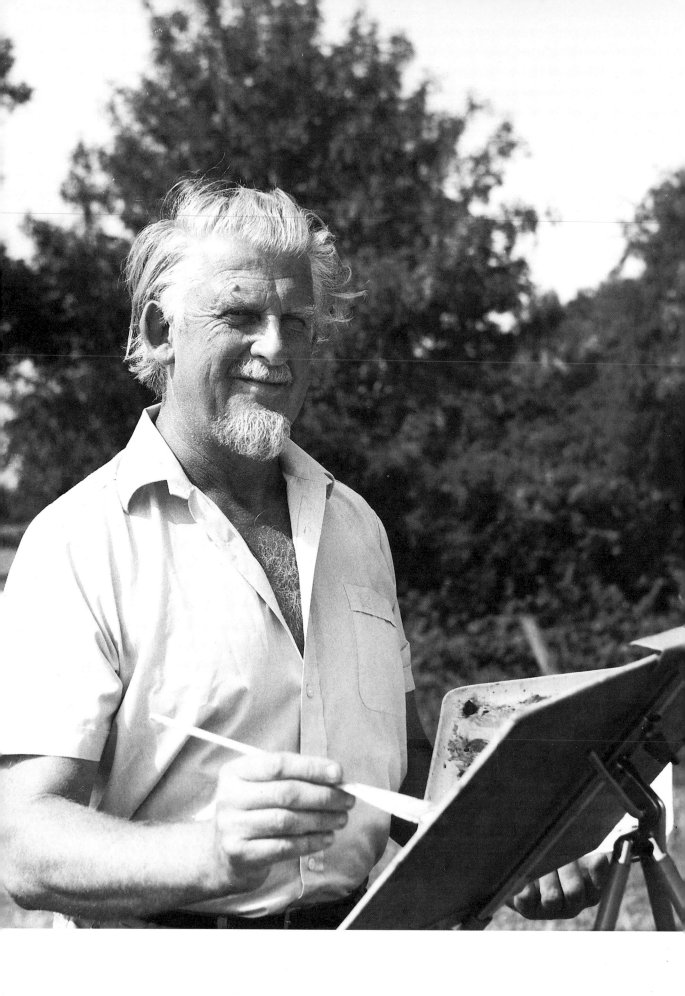

WATERCOLOUR
fast & loose

Ron Ranson

NORTH
LIGHT
BOOKS

Cincinnati, Ohio

Acknowledgements

I would like to thank Liz Madge for typing my manuscript and Ann Mills for helping me to edit it. I would also like to thank Leslie Moore, Douglas Treasure, Trevor Chamberlain, Roy Perry, Jon Peaty, Mrs Edward Wesson, Mrs Angus Rands and Mrs Peter Seymour for giving me permission to reproduce the paintings in the last chapter.

First published in North America 1988
by North Light Books
An imprint of F&W Publications
1507 Dana Avenue
Cincinnati, Ohio 45720

ISBN 0-89134-225-7

First published in the United Kingdom 1987
by David & Charles plc

Printed in The Netherlands

contents

introduction

Two or three years ago my first book on watercolour came out, and much to my surprise and delight became a best seller.

This is another book in the same mould, the basic philosophy being the same – to sweep aside the false mystique, and let you know how much excitement there can be with watercolour painting. So many of my students have said that they find it difficult to simplify the subject in front of them, so I've included eight demonstrations covering this aspect.

I make no claim to be an 'academic' – in fact I've had no formal training in art at all. I started to paint in my fifties after losing my job as a publicity manager. Of necessity, I had to learn my craft quickly so went about it in an unconventional way, without being held back by tradition.

Most of my techniques are in fact based on practical common-sense and a bit of home-spun psychology – trying to make up for lack of theory with almost unlimited enthusiasm! Which is highly infectious stuff, and I can almost guarantee that you'll be itching to try my methods.

The title of the book says it all, *Watercolour Fast and Loose,* the aim being to produce loose, impressionistic paintings which so many students yearn to do but are held back by their inhibitions which produce safe 'tight' work. The best way to overcome this problem is to work fast with a big brush. However, if you find that the paintings are not to your taste – put the book back on the shelf!

Running watercolour workshops at home all year round and also courses as far afield as Greece, Australia and U.S.A. means that I meet and get to know hundreds of students of all nationalities, who all seem to share the same needs and even make the same mistakes! This book is based very much on the things they want to know.

While many books show superb professional paintings which seem to set standards completely unattainable by the vast majority of their readers, those shown here can be and *are* attained by even the late starters – with perseverance.

Perhaps this is best expressed by a charming lady workshop director in the U.S.A. who wrote recently asking me to run a course on the coast of Maine. Her list of tutors were obviously the best and most famous artists in the States, but most of the courses seemed geared to the advanced, experienced student. Her letter finished, 'Those of us who have been intimidated need your help' – I accepted by return of post!

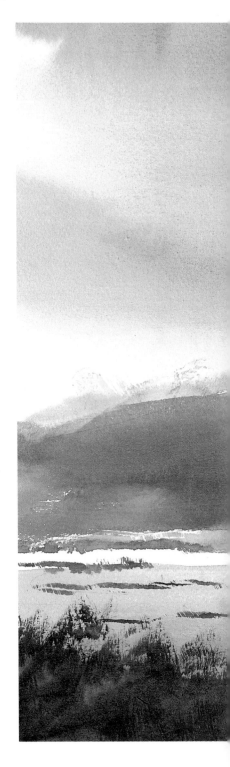

A scene in The Lake District with
'wet-into-wet' rain clouds approaching.

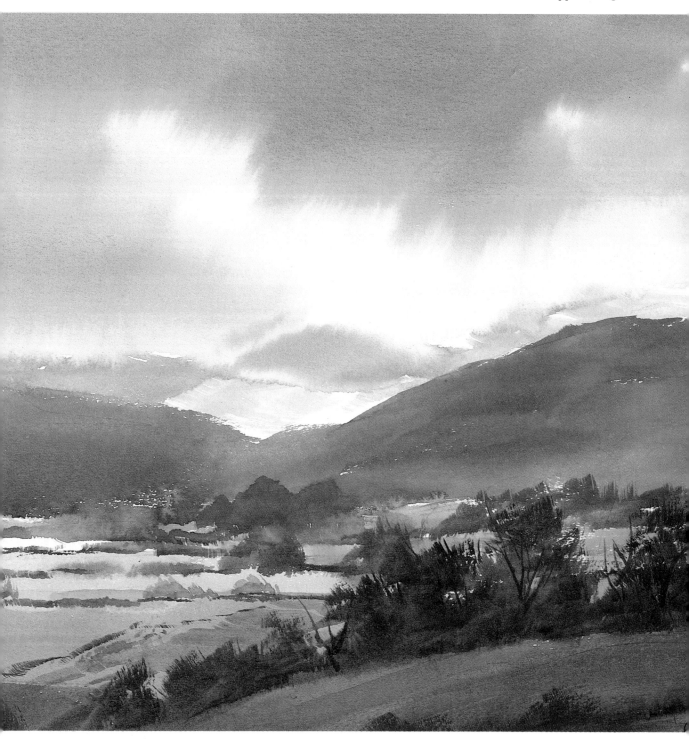

talking loosely

One sometimes has the feeling that the 'high fliers', the 'Pavarotti's' of the art world, somehow live on another planet to the rest of us, who figuratively sing in the local operatic societies.

As amateur painters, we may gaze open-mouthed at the work in many art instruction books showing superb techniques and marvel at the pure virtuosity of the *Maestro,* but often this work seems to bear little or no relationship to the struggle to hold one's head above water in our own Art Society!

What this book tries to do is to relate to you, much more directly – figuratively putting my hand on your shoulder to try and sort out your problems, rather than blind you with science! It's easier for me, because I relate to you infinitely more closely than to the hierarchy of the watercolour world.

To most of us, watercolour is a psychological struggle – with ourselves! Just getting the materials out and starting, sometimes requires a big effort. It is perhaps all down to a fear of failure – spoiling that lovely sheet of white paper we've paid good money for – why ruin it? We often put off that crucial moment of starting to paint by finding all sorts of menial tasks to justify the delay. Now, as a writer, I do the same thing! This book was delayed for weeks while I sorted out drawers, sharpened pencils and went shopping!

In my first book I talked of the fears, which most of us have, blocking the way to loose, free painting. In my own lecture-demonstrations I try to lay all these out on the surface and have a good laugh at them. People come up to me afterwards, saying they thought that they were all alone in having these feelings of timidity. It all shows too, in the tightness of their finished paintings – the reluctance to make a bold, confident statement, preferring to edge forward tentatively, with weak, watery washes, resulting in a completely anonymous, muddy meticulous painting, with little of their own personality showing through. It's rather as if they'd written their signature carefully and slowly, one letter at a time.

There are three factors that contribute towards the weak, fussy watercolours that so many beginners produce. First, the inexplicable reluctance to squeeze enough paint out before starting, it's called 'meanness' or more officially a 'starved palette'. Second, this combines with a tendency to use far too much water, makes it almost impossible to produce good rich darks, first time. Finally, that greatest disease of

watercolourists — 'fiddling'! That dreadful urge to over-elaborate, (I call it knitting or crocheting) on top of a perfectly good painting until it's ruined and cheapened. Almost the most difficult problem a student faces is knowing when to stop – that crucial moment when you've said enough and the painting rapidly starts to go downhill.

This book is aimed at the 'would-be' impressionist water-colour painters who really want, in their hearts, to 'loosen up'. To me two words are all important when producing an impressionistic watercolour – purity and simplicity. Purity is the transparent quality, so vital in a watercolour. It comes from a direct, sensitive application of paint, followed by an absolute determination to leave that paint alone, and not to 'fuss' it, which is probably the most difficult thing of all!

Simplification also takes some doing because the natural tendency for all of us is to add more and more detail. This may be because we're inclined to look at the various components of a scene, one at a time. If you decide that the distant hillside is what you want to focus on, paint it as you see it when you look straight at it. If you're concentrating on this area, however, you'll find that out of the corner of your eye, the foreground appears indefinite, therefore, handle this foreground broadly, avoiding the temptation to make it over-elaborate. On the other hand, if the foreground and middle distance are what attracted you in the first place, then concentrate on these parts and let the background hills be treated very simply.

Perhaps the most common mistake made by beginners when painting landscapes, is that they try to say too much in any one picture. If one 'overloads' a painting with too many items of interest, the main aim of the painting will be ruined, and the result will be a complex confusion that says nothing. Here's a very important thing that you should always keep in your mind – a good watercolour results from knowing what to leave out. This is far more important than knowing how much to put in. You'll find as your skills improve and you gain experience you'll gradually strip away the 'clutter' from your paintings, and hopefully produce purer, and more direct statements.

Simplification is also trying to capture the mood and not the detail, which means working, as fast as you can manage, to capture the effect you want. Sunshine and shadow won't hang around and wait for you! The light on the scene and the mood may be exciting when you start to paint, but might look quite

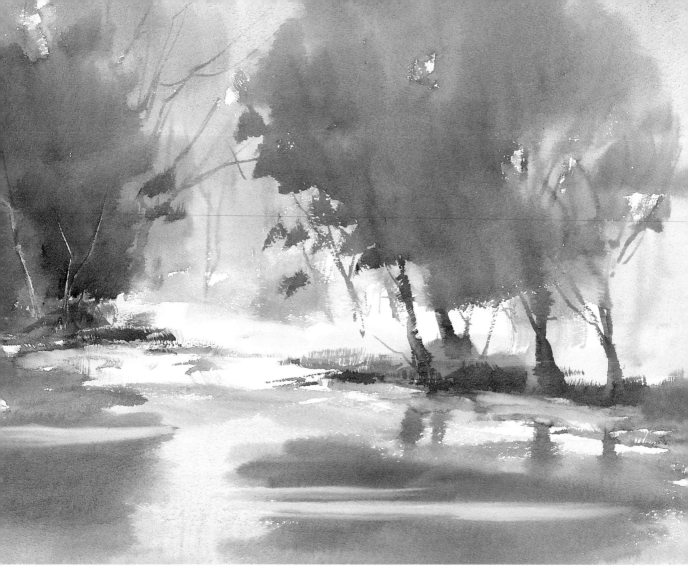

ordinary and commonplace an hour later.

Don't do too much pencil work before starting to paint, just sketch in the main shapes. Often too detailed a drawing tends to reduce the painting operation to a kind of 'filling-in', rather like a child's colouring book. Also, you may change your mind during the painting process, and want to alter something you've carefully drawn in. Your style might become stilted and cramped as you follow the lines you've previously drawn in, so let your brush do most of the drawing – it will then look a lot more spontaneous.

One of the main aims, both in England and abroad is to relax and instill confidence in my students, which in turn helps them to loosen up their paintings. They gain this confidence by learning to be in complete control of their brushes and techniques. This is often neglected as most watercolourists seem to want to give a 'concert performance' every time, without bothering to do their 'five finger' exercises.

No one can write a beautiful poem without first acquiring a proper vocabulary. One has to get down to the essential skills of the craft, before one commences pretty pictures.

A very loose watercolour done from imagination with the 'Hake' and the rigger.

the materials

This is going to be a short chapter because the materials I'm going to show you are few, simple and reasonably cheap to buy. You'll find no expensive sables, beautiful colour boxes, and various devices like candles and salt here!

In truth, the whole collection is a bit unconventional – but then so's my whole approach to the subject! Each item has a logical reason for being there, specially chosen to overcome most people's watercolour inhibitions. You must judge for yourself whether or not you think they're sensible for you. I have deliberately cut down everything to the bare essentials, but trying to get the very utmost potential from everything. This, of course includes the paints, which are restricted to seven – but of course everyone has their own favourite selection which they may have evolved over the years, and I certainly wouldn't be so dogmatic as to say that my own list would suit everyone. What is important is that although there are only seven of them I use the same collection whether I'm painting in the U.K., Greece or Australia! I strongly feel that the fewer colours we have to know about, the better we'll get to know them. Because there are only a few, we quickly get to know the possibilities of each in relation to the others. However, here's the list: Raw Sienna, Ultramarine, Lemon Yellow, Paynes Grey, Burnt Umber, Alizarin Crimson and Light Red.

I buy the large 21ml tubes of Winsor and Newton Cotman Colour – much less expensive, and there's more of it than the Artists' quality tubes, which allows me to squeeze my paint out with complete abandon. I gave up using pans of colour soon after I started painting, finding it too restricting and slow for my style of painting, and with my big brush they would be completely impossible. One can get instant response and instant power from a large dollop of rich moist paint. There's nothing so disheartening and frustrating as scratching around with too little paint! It's known by oil-painters, too, as a 'starved palette'.

I must say, here, that I've nothing at all against Artists' quality paints except the initial inhibiting factor. If you find you can handle the more expensive paint with generous abandon, use it by all means.

Another psychological trick I play on myself is to buy boxes of each of the colours and stack them up in front of me in my studio, then I know at the back of my mind that there's always plenty of paint left. This can apply too, to that other

expendable item – watercolour paper.

Next the brushes, again chosen to make you and me 'loosen' up, and work more directly with fewer strokes. In my first book I had four, but since then I've managed to reduce them to three, each one having its own specific purpose.

First, there's the flat 2-inch Japanese brush called the 'Hake', made of pony hair. At first glance this looks a ridiculous tool for producing sensitive work – but after a demonstration of only a few minutes, doing tiny thumbnail doodles, new students can't wait to get their hands on it. The trouble comes when they expect to use it straight away without any practice and get the same result! (More of this later).

The next brush down in size is my 1-inch flat, made of man-made fibre. This has an entirely different character to the 'Hake'. Sharp and with an accurate edge, it's used for painting such things as buildings, boats and fences, crisply, with the absolute minimum of strokes. I abandoned the ½-inch version, finding I could get the same effect by tipping the 1-inch slightly on one side.

My last brush is a Number 3 long-haired Rigger – my own is Dalon Series 99. (It's called that because in the old days it was used for painting ships rigging). The long hair which is about three times longer than that of a normal brush makes it very flexible. It's ideal for all 'calligraphic' work such as branches, grasses and figures.

My palette was bought in a hardware store – not an art shop! It's in white plastic, usually called a butchers tray, about 12" x 16", but I have in fact about a dozen of these stacked in my studio. They're very light, and provide plenty of room for mixing the paint. I feel too restricted by little wells. You can of course buy similarly sized, specially designed, palettes from art shops, but the main requirement should be plenty of space.

Now to the paper itself – there are so many to choose from in various thicknesses, surfaces and prices! One gets tempted by

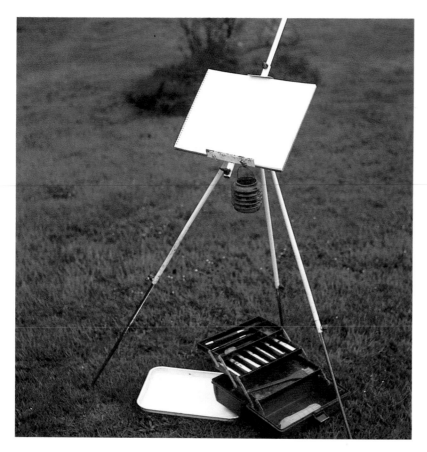

My 'outdoor' kit, consisting of a simple steel easel, collapsible waterpot, plastic art bin and palette. The spiral-bound book contains 140lb Bockingford paper.

continental paper with such exotic names as Fabriano and Arches. I've got sheets of these lovely things, all kept for 'Sunday Best'. Recently, one of my students proudly boasted that she'd got a drawer full of pre-war Whatman paper at home, 'What's it like to work on?' I asked enviously, 'I don't know, I've never had the nerve to use it', she replied!

For every day normal paintings, my own favourite is 140lb Bockingford paper, which is much cheaper than the hand-made sheets, and much less inhibiting! I nearly always use it in wire bound books of 12 sheets, called 'Langton Pads', in either 12" x 16", or 16" x 20" sizes. This is because it's easier to carry around and is instantly ready for use, without bothering with such things as drawing pins, tape or clips. This also avoids cockling too, because the paper is allowed to expand and contract unrestricted, so I never have to stretch it. In fact I've never stretched a piece of paper in my life – and I don't intend to! It all looks too rigid and inhibiting after all that preparation.

On these two pages you'll find an illustration of my outdoor kit ready for action and another one of the corner of my studio. The outside set-up is a simple metal easel, with my pad on a piece of hardboard backing. My little expanding water pot hangs from a hook on the easel with this is my plastic fishermen's box. The whole lot can be carried under one arm, leaving the other hand for opening gates – it couldn't be simpler! When going abroad I take the easel to bits and pack it in my case amongst my clothes.

Over to the studio – this set-up looks very elaborate, but mostly consisting of things adapted from 'finds' in second-hand shops. The white table is a plastic coffee table on casters. My easel is an old adjustable draughtsman's table rescued in a very rusty state from a scrapyard. Now repainted and covered with a plastic laminated top it's perfect! I can adjust the angle instantly and wipe it down at the end of every painting. The original parallel rule fixed to wire holds my paper on the top edge. The water jar was originally bought as a storage jar from a 'Habitat' store. A glass topped table has been made from a flush door, on top of an old dressing-table.

Part of my studio showing the restored draughtsman's board, covered with formica, with white plastic table and plan chest.

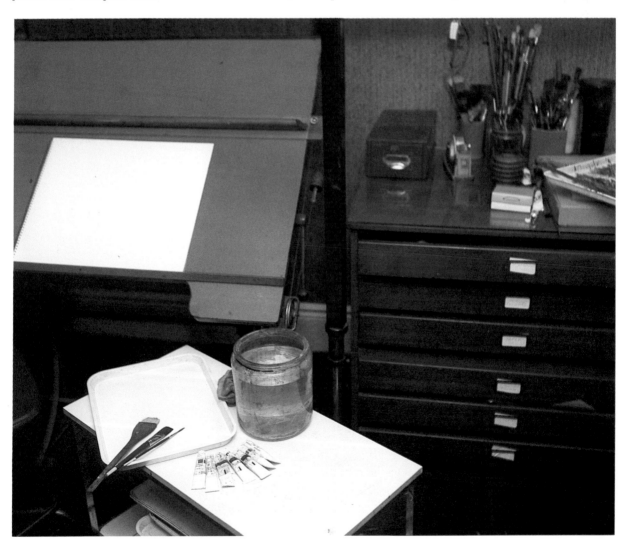

tools and techniques

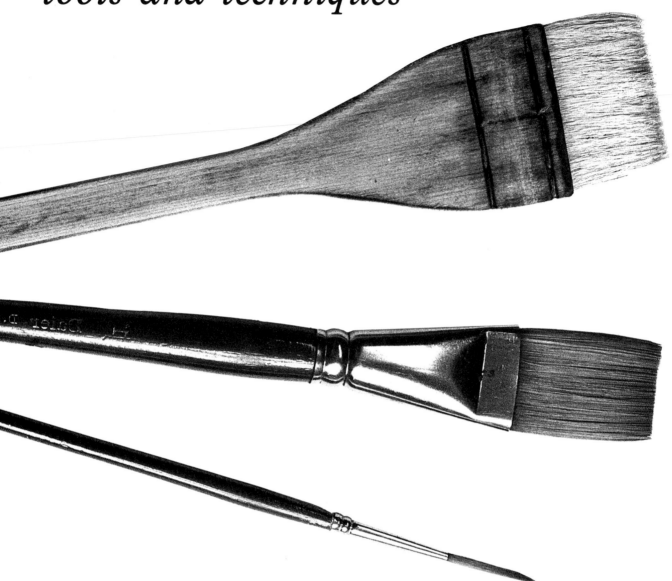

The key-stone of my 'fast and loose' technique is the 'Hake', a 2-inch wide traditional, Japanese watercolour brush. It is made of pony hair, stitched into a long, flat handle. I've been using it for some years now and it's transformed my way of painting.

Let's face it, it looks an ugly brute, especially when it's well worn and dirty! (There's no paint or varnish on the handle to keep it 'easy to clean'). Some painters try it for half an hour, then put it away and never use it again – there must be hundreds of these lying about in drawers! However, if you do persevere with it and learn its idiosyncrasies, it gives you a boldness, speed, sense of freedom and looseness that you can't get with a smaller brush – mind you I'm shamelessly prejudiced! It evokes a new attitude of mind, forcing you to simplify, by its very size – saying in one stroke what would have taken five before. You've heard the good news, now the

A simple study produced entirely with the 'Hake', with the yacht's sail lifted off by rubbing gently with a damp cloth between two pieces of paper after the painting was dry.

bad! First it holds a deceptively large amount of water, which is probably the most common reason for its rejection by many people after a short trial period. Unless the excess water is removed by touching it on a cloth or a quick shake on the ground, if you're outside, it dilutes your paint too much, and your colour becomes weak and out of control. In fact the correct water content is the hardest thing to learn, it's only done by trial and error. The second thing is that because it looks clumsy, painters handle it crudely, whereas it must be treated delicately with a feather light touch to discover its real potential. Don't think you're going to learn it in an hour, or even two, but if you persevere and get over the 'hump', you'll begin to love it and it will go a long way in helping you to paint 'fast and loose'. It's very difficult to describe in writing or even

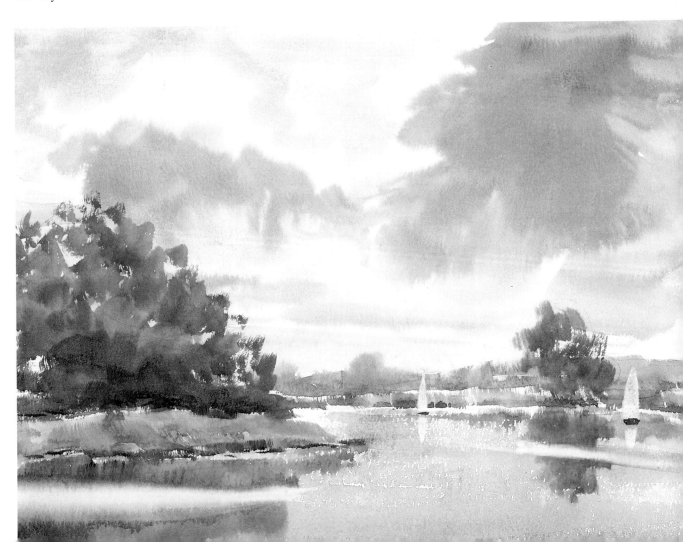

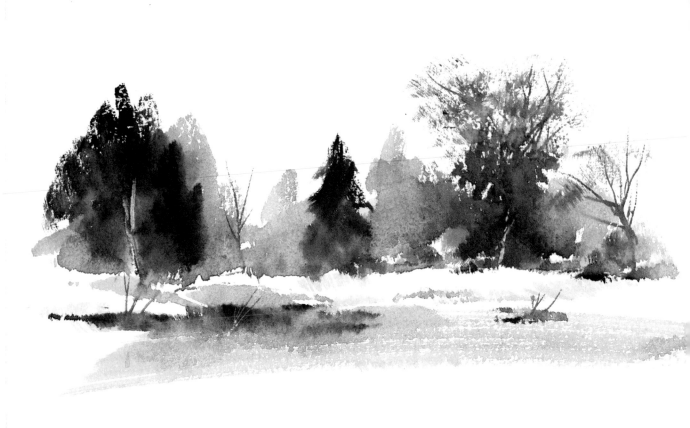

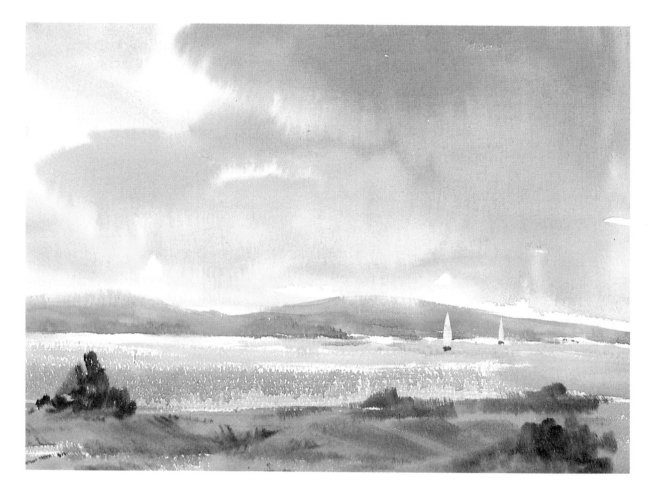

Opposite
A simple exercise done with the 'Hake' and the rigger.

Opposite and below
Two more scenes done entirely with the 'Hake', the light on the surface of the water below was taken out with a dry brush on a still damp surface.

pictures, the way in which you can use the edge, the corners and the heel of the brush to obtain the various effects or the speed in which it can render clouds, trees, and foregrounds – things that often get painted too laboriously.

The other two brushes are in complete contrast, the rigger is a long, very flexible brush which, depending on the pressure you put on it, can provide a line ¼-inch wide right down to the width of a hair! It's absolutely invaluable in painting winter trees with gradually tapering branches, fine foreground grasses, and figure work. I'm afraid this brush too, needs a fair amount of practice to control it properly, and enable you to use the brush to its full extent. Try holding the brush not in the middle, but right at the end of the handle giving it a much more flexible stroke. If you want a tapering line you should keep your hand still and just move your fingers – it's the action of the brush coming off the paper in an arc that gives that delicate stroke. If I'm doing country scenes, woodlands, rivers or lakes these are the only two brushes I use.

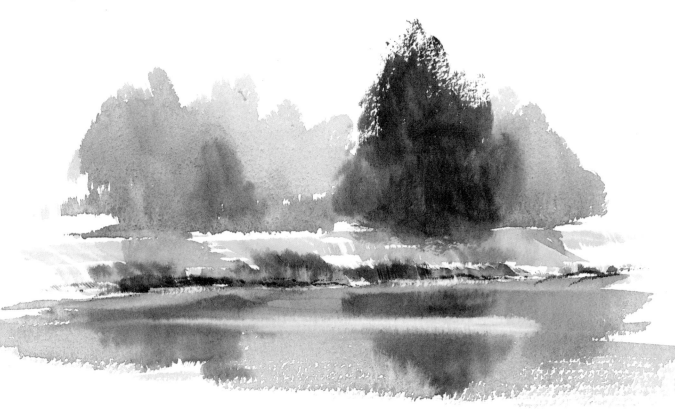

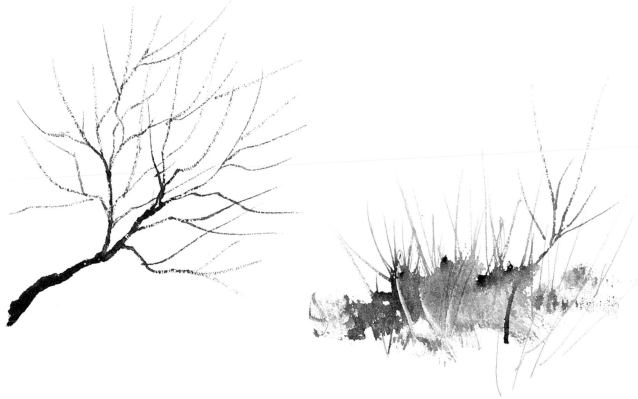

When I'm painting houses, boats, walls, fences, anything that has a sharp edge I use my 1-inch flat brush. When wet, it forms an absolute 'knife-edge', and can be used with the utmost economy of stroke to indicate such delicate things as the masts of distant yachts or railings. Again, you should try 'doodling' with it for an hour or so. You'll find it excellent for indicating distant buildings, boats, or boat sheds etc. You can get a general impression of detail without actually doing much work at all! But don't try to make it do trees – the 'Hake' is much better for this purpose.

So there you have it – the three brushes, each with their own tasks and use. Combined together, they help you to economise in strokes, and produce the maximum effect with least possible effort! Let me say here and now, in case you're wondering, that using these three brushes won't mean that everyone begins to turn out similar looking paintings. It doesn't work out that way at all, any more than a hundred identical pens given to different people will result in a hundred identical signatures. You'll be amazed at the wide range of styles turning up at the 'crit' at the end of each course – even though everyone has used the same three brushes. The most surprising thing, however, is when they compare these paintings with examples of their past work they bring along with them. Against their very tight and weak previous work they find a new sense of freedom and looseness.

Now let's turn to the various techniques themselves. I don't much like the word 'technique', it implies a slick mannerism which is the last thing we want. Most important of all, the technique should never dominate the content of the painting itself. It should be an unobtrusive thing that the viewer is

20

Some of the uses of the rigger
brush shown on the right. The
river scene shows rigger work on
top of a wet-into-wet background.

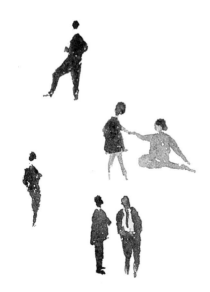

unaware of – just being free to marvel at the freshness and atmosphere of your picture.

The painting should, if it's to be visually exciting and avoid monotony, contain a range of different contrasting textures, each of which should complement the other. As I said in my last book, it's rather like an orchestra with the rich brass contrasting with the mellow strings and the clear tones of the reed instruments to form a complete, satisfying all over sound.

Don't get carried away with any one technique, trying to impose it on all your paintings. For instance, however much you enjoy our wet-into-wet for its own sake, (I do myself) don't use it indiscriminately, or you'll end rather like a singer with only one song to sing!

There are no magic methods or easy ways of painting pictures – though many of us, before we learn better sense, leap on to tricky devices we've heard about, which just might turn our pictures into masterpieces! These may include, salt, wax, scraping with various objects, and rubber masking fluid. The last one, I must admit, I do use, in perhaps one in a hundred of my paintings, but only if I have to – such as delicate sails of a windmill against a stormy sky. Most of these become a bit boring if used too regularly, they're really no substitute for talent. The less you disturb the delicate paper with such things, the fresher it looks. A watercolourist, particularly, needs to speak through a sensitively felt technique, to give an illusion. Not a slavish copy of nature, but your own interpretation of it, letting your own personality show through. My students are always restricted to one colour, Burnt Umber, on the first day so that they can get down to the 'nuts and bolts' of their craft, often previously neglected.

In producing straightforward washes, with the 'Hake' the main difficulty is that, initially, students don't produce a wide enough tonal range. On a scale of one to a hundred, if white were one and black a hundred, most of them seem to hover between forty and sixty, giving a flat, monotonous look to their finished paintings. Rather than bore them to death with flat washes, I give them thumbnail scenes to paint which absolutely need wide variations of tone. Basically, using very little water and a lot of paint you can get a very dark value, add a little more water and you get a middle value, add still more water and you get a still lighter value. It sounds so simple, but judging that water content accurately needs much practice, and

21

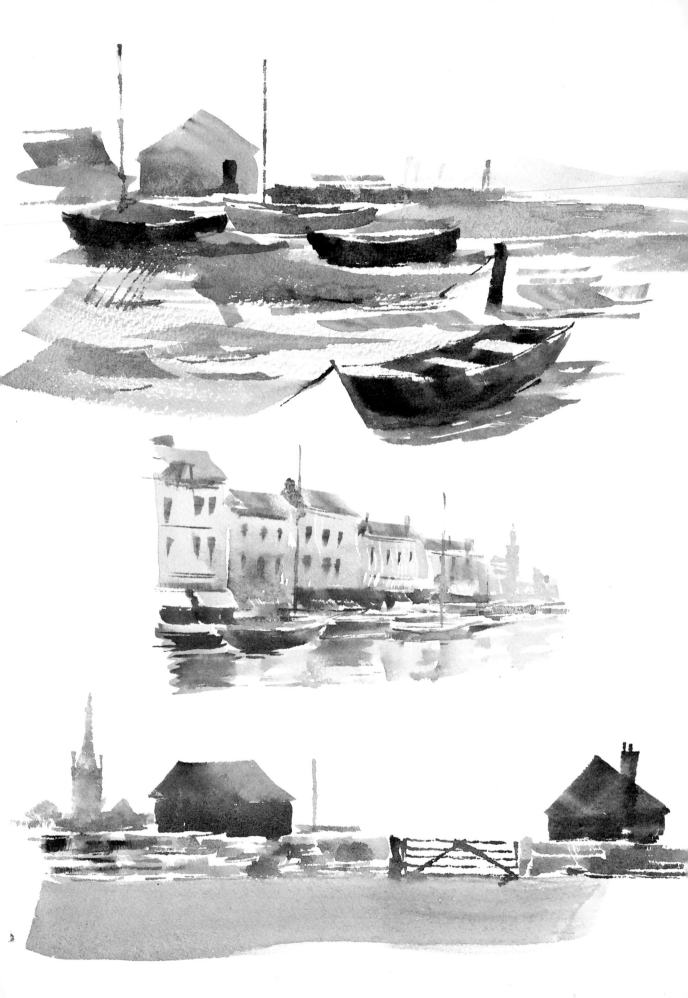

Opposite and below
Exercises produced entirely with the 1-inch flat brush, used very lightly and economically.

I'm afraid many sheets of paper as well!

Now to *wet-into-wet*, probably the most exciting experience in watercolour, but the very name confuses many students who put wet paint on an already wet sheet of paper, the result being a runny, vague mess, completely out of control! What you must get firmly into your mind, is that the paint only needs one lot of water to be controllable. If there's plenty of water already on the paper you can use the paint thickly, almost straight from the tube. It will then soften off on the wet paper, but still stay rich and controllable – it seems to take two days to convince students of this!

Anyway, that's the main pitfall – now try it out for yourself, if necessary copying some of these doodles shown here, but make sure you understand the process thoroughly. Try also some of the cloudy skies later in the book – they're wet-into-wet too.

Dry brush is in complete contrast again, and a good foil in terms of texture to all the softness. First remove the excess paint on to a rag, and then lightly and quickly drag the brush across the paper. The paint then just hits the raised surfaces of the paper. Even here you should be able to control its tonal value – try a dark dry brush, middle tone and a light dry brush – it's all very good practice. I find a dry brush is very useful to suggest the bright shimmer of sun on water.

Although I haven't shown it in the materials chapter, a small hogs hair oil-painting brush is very useful for correcting and softening edges, used gently, with clean water and a dry rag to dab with, it will remove small areas almost back to the white paper.

I also use my fingernails discreetly on a damp surface to indicate light grasses, or branches. Even my knuckles are used to produce texture in the foreground!

As I've said before, each technique is there to interpret a particular aspect – nothing more – so don't get preoccupied with effects for their own sake.

tonal values

To me this is the most important chapter in the book, simply because the ability to really see tonal values is by far the single most vital factor in watercolour. You start with a blank sheet of paper which has height and width – just two dimensions. It's your job to give the illusion of the third dimension, which is depth, and you can only do this by using the right relationship of tonal values. This is infinitely more important than minute detail. A very simple statement will create the illusion of reality if the tonal values are right.

Let's get the idea of the value explained first – it's simply the lightness or darkness of an area, shape or object – nothing to do with colour at all. When you're painting from nature you've got to be constantly looking for the difference in tonal values between one object and another. Keep asking yourself as you work – is that lighter or darker than what stands next to it? Of course, in nature there are an infinite number of tones, and it's your job as an artist to reduce these, if possible to three basic tones. Your lightest light, as a watercolour artist, is the white paper itself, through the middle tones to the darkest dark.

A really good test as to whether tonal values have been used correctly in a painting, is to photostat it in black and white. If the artist has used only colour to get definition, and hasn't considered the tones correctly, the picture will look completely formless and anaemic in black and white. A high proportion of students' work would, I'm afraid, show up badly in this test.

But, how do you go about getting these tones right in a painting? The answer is to analyse the tones of a scene in relation to each other and reproduce them faithfully. My own way is to screw up my eyes very tightly – just being able to see through them – this seems to make various tones easier to understand.

The trouble is that most students are so intent on mixing up the right colour that they often ignore its lightness and darkness. What makes it worse is that they forget that their washes always dry lighter, which tends to leave the painting flat and lifeless. My own way of overcoming this, in my classes, is to restrict the students, for the first part of the course, to one colour – Burnt Umber, making them paint their pictures only in this. After a short time they soon begin to understand and increase their tonal contrasts, without having to worry about colour mixing. They get this by widely varying the amount of water in their paint.

24

Try some thumbnail sketches in Burnt Umber, using these three values, holding back the lightest light and the darkest dark, shown in the two tiny squares, use them discreetly at the end to attract your viewer's eye. Lots of practice like this will teach you not to break up your pictures with too many spotty lights and darks.

The next step is a tonal value sketch or sketches, which should be done before you start any finished painting. These can be done very small, perhaps two inches by three inches, and very quickly, with absolutely no detail, just a strong visual impression in either soft pencil or in washes of Burnt Umber – my own preference. Try to restrict yourself to just three tones. Planning the picture like this serves two functions – it lets you see the effect of the subject before starting the final painting and also, as the painting proceeds, it's a reminder not to lose the important tonal value relationships, as you add all the details on top. The funny thing is that professional artists almost always follow this procedure, whereas most students usually skip this stage altogether, and plunge straight into the final painting. To me it's rather like going on a long,

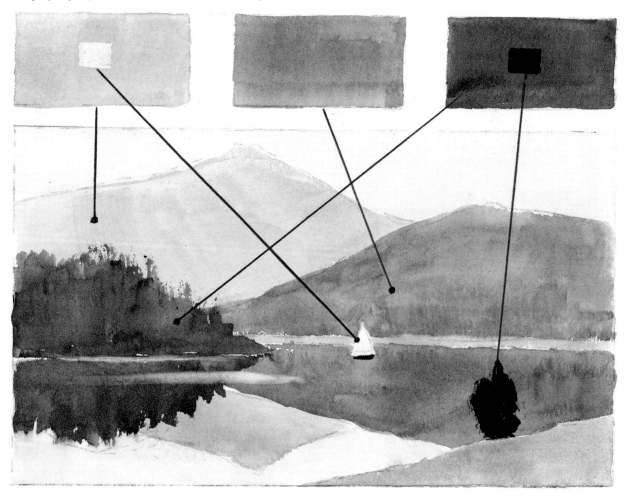

complicated journey without studying the map first!

Now let's go over a few of the most common 'tonal' mistakes. While a stretch of scenery might look very bold and impressive as you stand and look at it, transferring it to a small piece of paper one has to constantly and deliberately heighten the tonal contrast to make it an effective painting, and that's where the trouble starts. Most students use far too little contrast between light and shade, with shadows that are too weak and anaemic – in fact the whole painting lacks punch and excitement. I call this the 'tissue-paper' syndrome, because it looks as if someone has put a sheet of tissue paper over the top!

At other times, students seem not to realise their own power to alter. Unlike photographers, they can change a landscape around to suit themselves – a few more dark trees next to a white wall to give more contrast.

You can also manipulate tone to give better balance in the picture. For instance, a dark building on one side of a picture may seem to weigh it down. You can, however, balance this by placing a dark bank of cloud on the opposite side of the painting. A foreground shadow from an unseen tree is another trick, to keep up your sleeve, for getting better balance if necessary.

Now to a very important process in painting – *counterchange*. It seems hardly ever mentioned in most painting books and very often ignored by students. It is a deliberate painting of dark shapes against light, and light shapes against dark, or to put it in its most basic – a chequerboard pattern. It does happen a lot of the time in nature and often in a landscape, objects seem to be set against each other with this principle in mind. A dark building may be silhouetted against a light patch of sky, or a sunlit tree may stand out against a dark sky behind it. It doesn't always happen of course, but it's part of your job as an artist, not only to look for these contrasts of tone, but to be constantly and actively creating, and intensifying them, throughout your pictures – I call this 'stage-lighting'.

The Old Masters knew all about counterchange and used it constantly, just look at some black and white reproductions of their work. Remember, used imaginatively, this principle will give your paintings much more impact and atmosphere.

Now let's concentrate on depicting recession in the painting. One of the basic rules of tone painting that you must remember is that light tones seem to recede into the distance, while dark

Opposite
One common fault with beginners is to make the tone of trees and green fields the same. Whereas a field, being flat, reflects the maximum amount of light from the sky, trees are half in shadow and the lower foliage is shaded by that above it. When silhouetted against a light sky it appears even darker in contrast. Apart from that, leaves are mostly darker in colour than grass.

tones come forward. This illusion, of course, happens in nature and you can observe it yourself on any long distant view – it's called 'aerial perspective', and it should be an essential part of your painting technique.

As well as the tones getting lighter, the further away an object gets, the actual colours themselves weaken and become

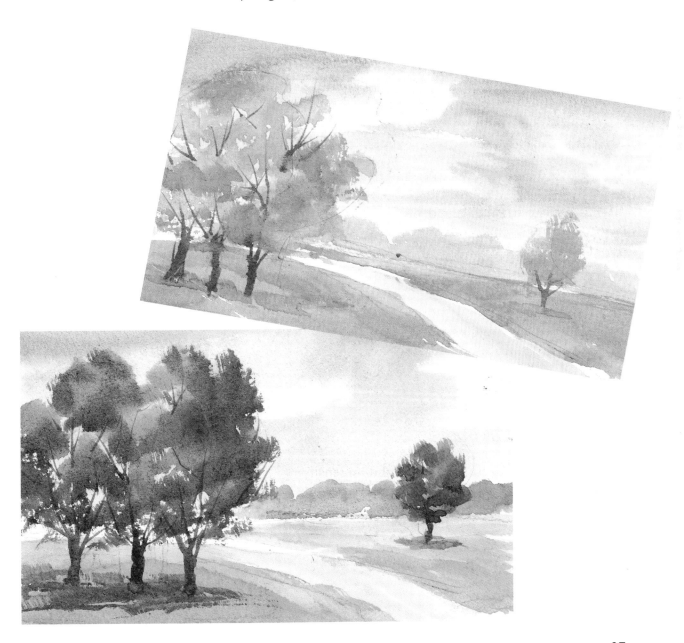

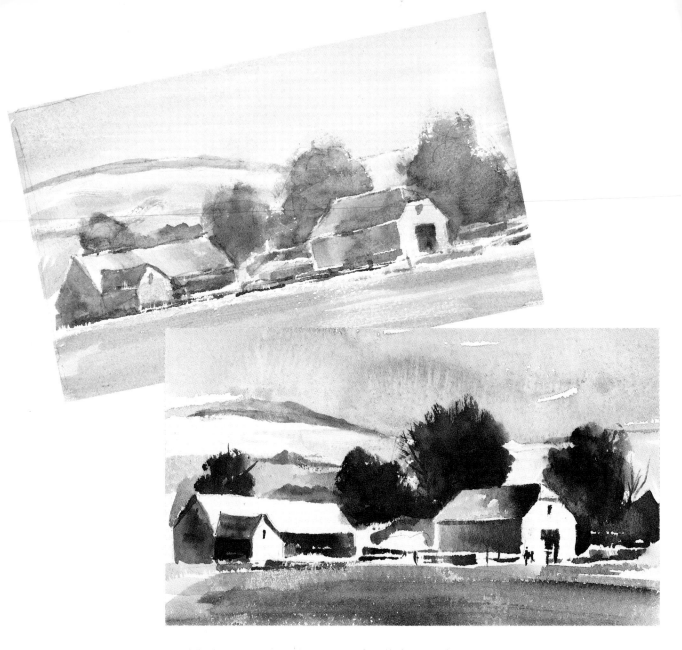

bluer and greyer, with less contrast between the lights and darks. If I'm painting a distant hillside or wood, for example, I nearly always paint it as a single flat wash, sternly resisting the temptation to portray the individual trees. As you move further forward you can increase the relative strength of your colour and provide more contrast between the lights and darks of any particular object.

I nearly always paint my watercolours starting from the background of a scene, moving forward step-by-step to finish in the foreground, painting in a 'whisper' at the back with a certain amount of wet-into-wet and using a lot more strength and sharpness towards the front of the picture. The big mistake some students make is to dodge about the various planes of a painting, often putting in that distant wood much too dark and leaving nothing in reserve for the foreground trees. There's that terrific temptation to go back and poke some more tone on a hillside five miles away, right at the end of their painting!

Photostating your paintings will often show up your tonal faults. Simply changing the colour of buildings and trees is not enough – they should also contrast in tone and counterchange with each other.

Painting recession in your pictures depends on using the right tones. Usually objects appear lighter, softer and less contrasting, the further away they are. Generally keep your strongest tones and richest colours for the foreground, and weaken or 'blue' them down in the distance.

Standing out like a sore thumb, it completely destroys the illusion. They also forget that their distant greens should be pale and blue-dominated, and they paint with a much too yellow-green, which again throws the whole thing too far forward. Try looking at the grass at your feet – compare the tone and richness of it with that of the grass two fields away, then again, at a mile away. So much in painting relies on actively observing and comparing.

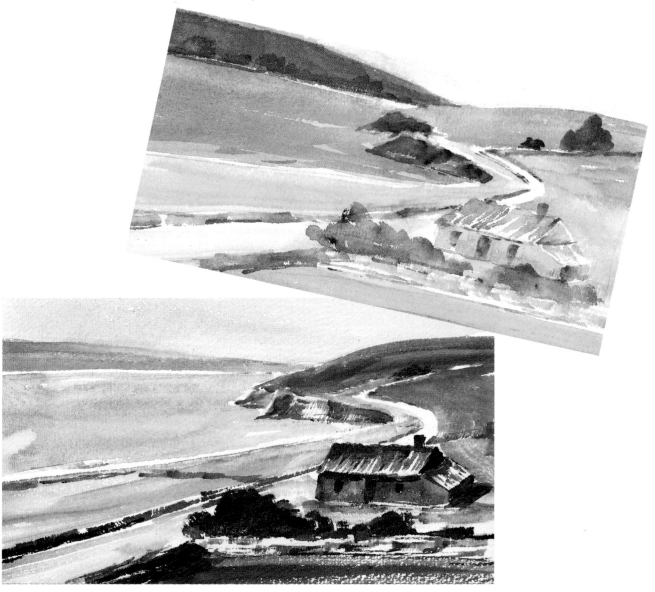

composing your pictures

It's very rare to be able to stand in front of a scene in nature, however beautiful, and be provided with a ready-made composition with a completely satisfactory design. A really good watercolour painting is usually a slight, but necessary, reorganisation of the subject rather than a slavish copying of nature's own arrangement. She offers you endless subjects with countless ideas for paintings, but it's up to you as the artist to take these ingredients and orchestrate them into harmonious compositions. The trouble is, though, most students have a good sense of design until they start to paint specific subjects. The problems of drawing and painting what's in front of them are so absorbing and overwhelming that organising the whole composition gets overlooked completely.

A good painting should be more than just a group of well painted parts. Each separate area may be thoroughly convincing, but the picture as a whole may look unsatisfactory. What it really suffers from is a lack of the underlying design. There's nothing that separates the professional painter from the amateur more widely than this area of abstract organisation. One often gets the impression as one talks to students about composition that they either nod wisely, or perhaps yawn behind their hands! They've heard all that stuff before about balance, movement and unity in a picture – they've even skimmed over it in books! But once they get down to the site, with their brushes poised, the thought never seems to enter their heads to rearrange anything, even slightly. They're so concerned with the actual struggle to get things down on paper that they record exactly what's in front of them – even to the barbed wire fence!

So this is a plea for a more critical look at nature – bend it slightly for your own needs and good taste. So often, when I'm

On the far left the composition is off balance and looks as if it is going to tip over. The centre picture is formally balanced but very boring. The one on the right is much more satisfying, with the large weight near the centre balanced by the smaller tree near the border.

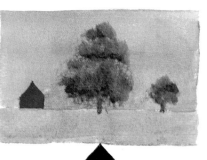

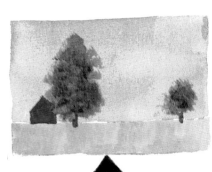

Above
Never divide your picture through the middle with half sky and half land – it looks dull. Far better to have either a high or low horizon which gives a more exciting design.

Below
Be wary of dull, monotonous repetition, since it will destroy spontaneity. Far better to vary the size and shape of your elements.

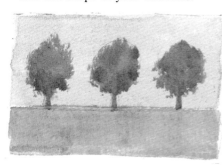

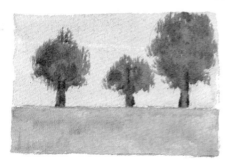

criticising a picture for being unbalanced, the student will say indignantly, 'Well, it *was* like that!' So in future, pay attention and resolve to try and modify your future paintings according to these basic rules, before you start worrying about your greens!

It's a bit like the fact that everyone knows there's a speed limit, yet just take a look at the outside lane on a motorway, you'll realise how few people actually stick to the rules when they're in a hurry.

Basically, good composition is largely a matter of good taste – but to use this taste you've got to reduce your chosen subject to an abstract pattern. So, what's an abstract pattern? Try to imagine all the details disappearing from the painting, leaving only the pattern of shapes plus light, dark and middle tones. If the painting itself is well composed the pattern it makes will still form a good design. Conversely, a poor composition will never break down into a good abstract pattern, and all the various techniques and pure washes will never make it into a really good picture.

The more complex a scene, the more necessary it is to search for a pattern that will simplify and unify all the various scattered bits. Without this pattern, a very busy painting falls apart, into a lot of little pieces, like a shattered window! By analysing this pattern you'll then be able to project the feeling of a scene without the fuss. Try applying these principles to your own existing pictures and see how they stand up to the criteria. It's more important to be concerned with a good design than with detail. For example, if you want to make a bridge or a figure a focal point of a picture, design the space in a way that leads the eye to it, but gently, not too obviously. Curved lines are far better for this than long straight ones which rush the eye to it too quickly.

Of course, there aren't any set rules for guiding the eye to the

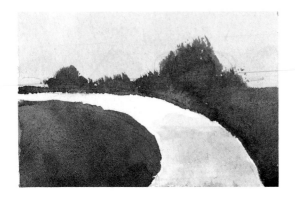 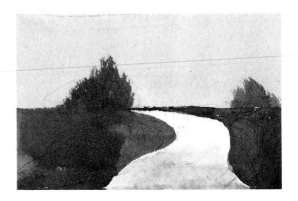

point of interest – each landscape presents different problems, but your main task is to tempt your viewer into your composition. One way to attract attention to your point of interest is to make it the area of greatest contrast. Every scene that's worth painting does have a central point of interest, so concentrate on that. If there happens to be another interesting feature in the subject, be quite ruthless in subduing it, so that the main feature is without competition – don't try to say two things on one piece of paper.

The centre of interest is the most important thing in your picture – probably the main reason you chose to paint it in the first place. It's the point of concentrated energy around which your painting should revolve. However, never, never, make it the geometric centre of your picture.

What makes a composition successful? The size and shape of the main masses and how they relate to each other are terribly important. If they're all equal in size, you'll have a static composition. If the picture space has been filled with too many little shapes, the result will be spotty and confusing. It's not only the shapes of your main elements, it's also the shapes of the in-between or negative areas.

Another hazard you should avoid is repetition – one of the biggest dangers in destroying spontaneity in a painting. Don't paint four trees in a row exactly the same size. You should actively and purposely vary their size and position. In fact, any two or more forms of similar shape should differ in size. For example, suppose you've got a large dark mass of a tree on the right hand side, you'll need a balancing dark somewhere on the other side. It can be smaller, because a smaller dark can balance a large one. If your main shapes aren't too alike in size, and your lights and darks are well-designed and balanced, the chances are you'll have a good abstract pattern.

A little viewfinder, made out of card, with a rectangular hole cut out in proportion to your paper is a big help in composing your pictures. However, it should be used properly – not a

The viewer's eye is usually led into the picture from the bottom, but make sure you don't lead it straight out again. It should be guided gently to the focal point within the painting.

quick squint through it just to show the world you're an artist'! Walk around with it, viewing things from different positions and angles before you finally get your paints out. You can in fact, teach yourself quite a lot about composition and judgement just by keeping the viewfinder with you all the time, using it to practice composing imaginary paintings even when you haven't got your kit with you.

Finally, lock permanently into your mind that you as an artist should take liberties – changing, elongating, moving, reducing or omitting a shape or shapes if it makes a more interesting visual effect.

You can often use tone effectively to balance your pictures, and if a scene is weighed down on one side. Skies and clouds can be manipulated easily to do this. Strong shadows from imaginary objects outside your painting can also be used effectively, especially in the foreground.

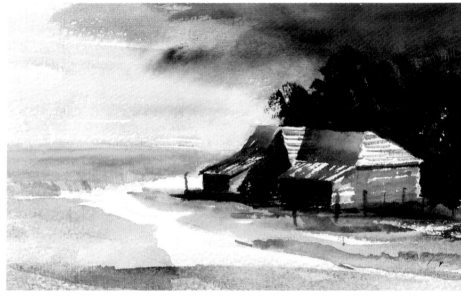

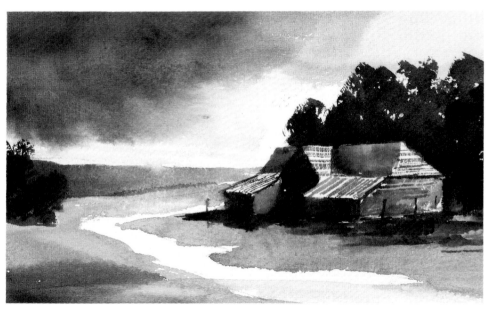

getting into colour

One of the most obvious signs of a beginner is often the excessive and tasteless use of colour. With all their colours squeezed out, they find subtlety and restraint impossible and all the basic rules of design and tone are forgotten.

As my students use the obligatory Burnt Umber during the first day – their confidence increases rapidly and so does their understanding of tonal values. But then comes the time that they're allowed to use the whole palette and so often their paintings immediately become weak and flat again! The solution is to tread quietly and cautiously into this sea of colour – learning as you go. You very rarely need to put all your colours out to do a particular painting. Think of your entire range of colours as a piano keyboard. You wouldn't, as a pianist, feel obliged to hit every note each time you play a tune. It's a question of letting your mood and good taste dictate your choice and number of colours. Often, after looking at a scene in front of me for a few minutes, I'll probably only choose four or five colours to work with.

But let's get back to the beginning, I'm not going to 'blind you with science' and talk about the theory of colour – you probably wouldn't read it anyway! My one real 'hobby-horse' is my belief that most people, including myself, work better with a limited number of colours. You then soon get to know them intimately and begin to judge instinctively how they react with each other.

A thing that students hardly ever do, but something I'd like you to do, is to forget, for once, about producing a masterpiece and just experiment with colour for a few hours. Working on cheap paper, learning what goes with what to make what, until you can do it instinctively. It makes sense doesn't it?

Back to my own seven colours, some of which you'll use a lot, some of them only occasionally and a single tube may last you a year. With each I'm going to give you a few ideas about mixing, but remember this is only to start you off – learn them by experiment.

Raw Sienna – my favourite colour. I use it in practically every painting, preferring it to Yellow Ochre because it's more transparent. An 'earth' colour, one of the oldest known, it has been used by artists throughout history. I use it often as a first very watered down wash, for my skies, which produces a pale cream colour, then graduate my blue from the top, leaving the original wash almost untouched at the horizon, but more about

this later in the book. Mixed with Light Red, it produces a warm golden yellow, for such things as stubbled fields, or mixed more richly for roof colours, especially in Greece. It's also good for sandy beaches, with a bit of Burnt Umber added for the darker areas. With Ultramarine it makes a good green.

Lemon Yellow – This is a straight down the middle, bright yellow; very strong and excellent for making greens. Add Light Red and a warm yellow results, with alizarin a bright orange.

Burnt Umber – A very useful 'earth' colour, mixed with Ultramarine it makes a wide range of greys by varying the proportions of each. To make almost black, as in a doorway, use it with Paynes Grey. It mixes, too, with Raw Sienna to make a mellow stone wall colour.

Ultramarine – this is a very strong blue so I hardly ever use it without mixing with other colours, one of my favourite mixes is with Light Red for shadows. It's useful, too, for mixing greens with yellow or Raw Sienna.

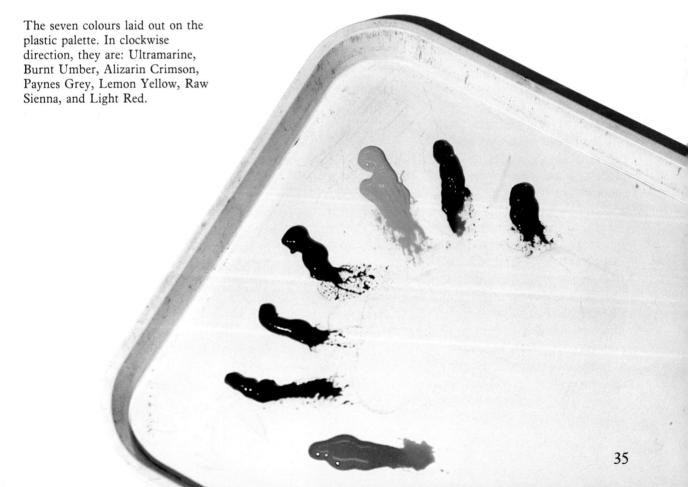

The seven colours laid out on the plastic palette. In clockwise direction, they are: Ultramarine, Burnt Umber, Alizarin Crimson, Paynes Grey, Lemon Yellow, Raw Sienna, and Light Red.

Light Red – another 'earth' colour and very fierce – in other words you don't need much of it! A sort of dull, brick red, which produces lovely terracotta colours with Raw Sienna. It's also good when mixed with Ultramarine to indicate distant trees and mountains. It warms up Paynes Grey too, to produce even more greys.

Alizarin Crimson – I don't use much of this – a little goes a long way. It's a cool intense red. Greatly watered down it makes a good pink. Mixed strongly with Ultramarine it makes a strong purple, and with Lemon Yellow an orange. I suppose my main use for it is to mix it with Paynes Grey for threatening skies such as on pages 38 and 39 for the underneath of cumulous clouds.

Paynes Grey – my most controversial colour. Hated by some artists, but I find it very useful for mixing with yellow for dark rich greens. Used thinly with Alizarin it also makes transparent shadows. It's very good for getting instant darks, but always mixed with something else, like Burnt Umber – never by itself, because it can dominate a painting. Also remember that it dries much lighter than it appears when wet. I don't use it at all in sunny climes, but it's so useful in England!

All the colours indicated above are permanent, which means that they're not likely to fade when the pictures are subjected to strong sunlight for long periods. The only one that's slightly doubtful is Alizarin, but that's used rarely anyway.

You'll see there are no greens there – I dislike made-up greens as do a lot of other artists, because so often they seem to bear little relationship to Nature's greens. However, it's very important that you should be able to mix all the various greens you're likely to need from the colours already listed. Greens in the colour spectrum range from nearly blue, right through to nearly yellow. There are cool greens, which lean towards the 'blue' end, and rich greens which incline towards the 'yellow'. But before you even start to paint, compare all the various greens of different trees. Some students don't even attempt to match the greens in front of them, but use a set mix, only making it darker or lighter. This results in a flat, monotonous and amateurish painting.

Let's take a normal bright green tree in front of you. Looked at a mile away it will not only appear paler, but also bluer or cooler. The further away it gets, the more this occurs – this is *aerial perspective,* and it's a valuable way in which artists can

depict recession. Most students know this perfectly well until they start painting, then they often show a rich dark tree two miles away on the horizon, sticking out like a sore thumb, instead of putting it in as a flat, bluey green, pale silhouette. Thus leaving enough leeway for the strong, richer greens as they come gradually forward towards the foreground.

Now let's start mixing then on the palette itself, put four colours out – Ultramarine, Raw Sienna, Paynes Grey and Lemon Yellow. Put your brush into the Ultramarine and make a patch of this in the middle of your palette, then add a minute touch of Lemon Yellow and you get a very cool, bluey green. By adding a touch more Yellow, the green starts to become brighter. By repeating this three or four times, adding Yellow all the time, you'll find you've produced a range of greens. Then start at the other end with a patch of Lemon Yellow and by adding a touch of Ultramarine you'll get pale yellowy green. By adding more and more blue, you get back to where you started from! When you add a touch of Raw Sienna to the mixes you 'richen' them, as opposed to making them brighter or cooler. To achieve a deep, rich olive green mix combinations of Raw Sienna and Ultramarine. To get a really dark green, try Lemon Yellow and Paynes Grey.

By now you should have produced a large range of greens on your paper. You should also learn to 'grade' them down for misty scenes, by adding a touch of red. You'll soon learn to enjoy your greens, rather than dreading them.

As I said at the beginning of the chapter, tread cautiously into colour and if you feel overwhelmed with even the seven colours I've mentioned, try working with two. I enjoy demonstrating various techniques using only Lemon Yellow and Paynes Grey. Another pair could be Paynes Grey and Raw Sienna. Then try three, Lemon Yellow, Ultramarine and Alizarin – the three primaries, then try four.

Your main task is to become completely aware and confident, instead of hopefully and nervously mixing them, without being quite sure how you're going to get that certain tint for a distant hill. Once you're in control of your colours, you can turn your whole attention to the task of depicting that beautiful scene in front of you, but keep your little tonal value sketch in front of you. Don't ever lose contact with the original tonal pattern – keep referring back to it. Like a map to a motorist, it will keep you from going astray along the way.

skies

There's nothing that lends itself so well to 'fast and loose' techniques as skies. With a big 'Hake' you can get a sky finished in about two or three minutes, but you will need 'know-how', courage and a bit of luck! The know-how you get by observation and practice. Although we see skies every day, we are all inclined to take them for granted, scarcely glancing up at them and regarding them only as a backcloth hanging behind a landscape.

Skies can be some of the most dramatic happenings in nature and their colour and cloud formation are often the major element in a landscape. Although it's possible to be fairly arbitrary in handling some sorts of clouds, it's essential to

Notice how the rain cloud on the right balances up the weight of the left hand trees. Here I dropped a mixture of Paynes Grey and Alizarin on top of a damp creamy sky and tipped the paper at a steep angle – gravity then did the rest!

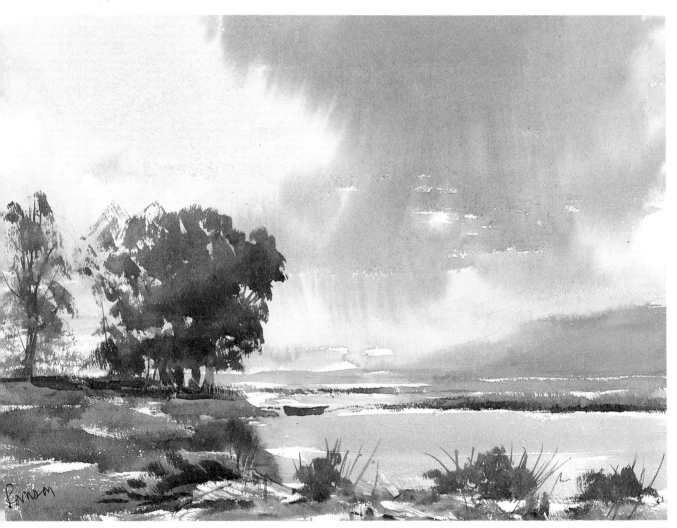

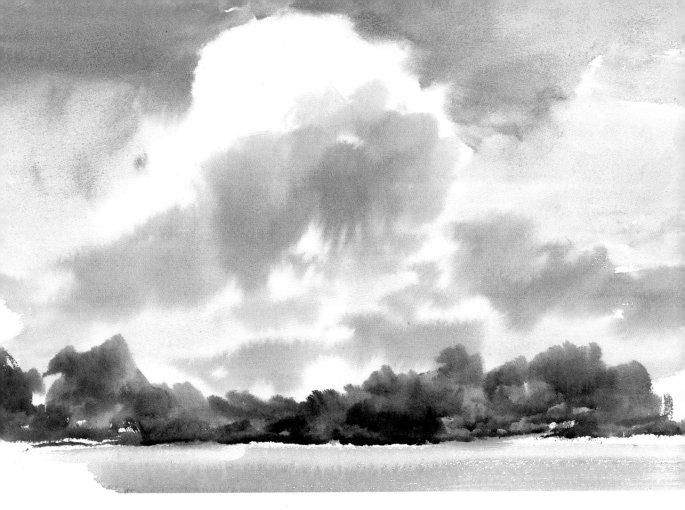

A Cumulus cloud. I painted a very weak Raw Sienna wash, and while still damp I painted round the cloud with blue, immediately putting the shadow underneath it with the Payne's Grey/Alizarin mix.

know the principles of cloud formation so that you can conform to nature as well as fitting them in your painting. Ideally, to learn skies properly you should paint one a day, in all weathers, then you would soon get the confidence and skill, but many of us, being human, wouldn't keep this up for long! The most I ever do, myself, is to regularly look up at the sky and mentally work out how I'd tackle it in watercolour. It's a bit like lying on your back and imagining yourself doing twenty press-ups!

Now to the second need – courage – a factor very lacking in many of my students, when it comes to putting in skies. Their chief fault is timidity and I've seen thousands of weak, anaemic looking skies. I'm always telling them you must frighten yourself with a sky. Make it much stronger and richer than you really think it should be, then it will be about right when the whole picture is finished.

Another thing they tend to do is to poke about with them, rather than make a firm commitment. They jab and push and dab out until the whole thing has lost its freshness and become muddy and tired – all through lack of confidence!

Ignorance of cloud formation shows up very quickly and so many students drop patches of dark tone into the sky, hoping that somebody will believe it's a cloud. So I'm going to run over quickly the three main families of cloud, these are Nimbus, Cumulus and Cirrus.

Nimbus clouds are harbingers of rain, generally rather low, heavy looking and dark. You see mainly the bottoms of these, especially when they cover the sky.

Cumulus is the summer, fair-weather, 'woolly' type – my favourites. They form great domes in the sky, but do notice their bottoms are flat. Being dense objects they need to be modelled convincingly to look authentic. I always think of them as pieces of cotton wool with a spotlight on top.

Cirrus clouds are very high, borne about by strong winds and their shapes are like long drifts in the sky. They can behave like blown snow, forming 'Mares' tails' or in ripple patterns when they're called 'Mackeral' skies.

More often though, your skies will contain a mixture of all three with even a patch of clear blue sky somewhere.

At this point it's very important to remember that clouds have perspective, just as obviously as houses or telegraph poles. They appear to get smaller and be spaced closer together as they recede towards the horizon. By accenting this affect you can get much more depth in your picture.

Let's start with the simplest condition – that of clear skies with no cloud at all. Beware of making them look too flat – they are nearly always much darker at the top, and lighter and creamier as they approach the horizon. My own method of painting, with my board at 45 degrees, is to put in a very, very weak wash of Raw Sienna over the whole sky with my 'Hake'. I then paint across the top of the paper with fairly rich blue while the first wash is still wet. I then work downwards with horizontal strokes, using less and less pressure – usually without any more paint, so that I get a weaker and weaker mixture, and I let gravity do the rest. Incidentally, one hardly ever uses raw blue paint, no matter how clear the sky appears, touches of other colour, with the blue, will make it look more atmospheric.

Another straightforward sky is a moderate overcast, with layers of clouds covering all the visible sky. Here again, a simple graded wash will do the trick but occasionally you can use strokes of darker colour where the clouds are thicker. Add these to your basic wash with a dryer brush.

Cumulus clouds are great fun to paint in watercolour, but you must work at a good pace to indicate their shapes and modelling while the paper remains damp. I begin by washing in very weak, wet, Raw Sienna over the whole sky, which of

course dampens the surface. I then decide where my clouds are going, putting in the large ones at the top and reducing to the small ones on the horizon. I paint the blue sky around the clouds quickly to get the shapes and once these are indicated I immediately put the bottom shadows to each cloud, basically with Paynes Grey and Alizarin Crimson mix. All this is done while the original Raw Sienna wash is still damp. Once that is done sit back and watch the sky soften, as the washes blend slightly. I warn you though, it does take experience to gauge the right amount of water for each successive application.

Sunsets seem to hold a particular fascination for students, I remember one lovely course on the island of Herme, where everybody seemed to line up with their easels 'at the ready' ten minutes before each sunset. Get everything ready, with the paint squeezed out on your palette and when the time is right,

This is a mixed sky with various types of clouds at different levels. Notice too the placing of the main cloud to balance the black hut.

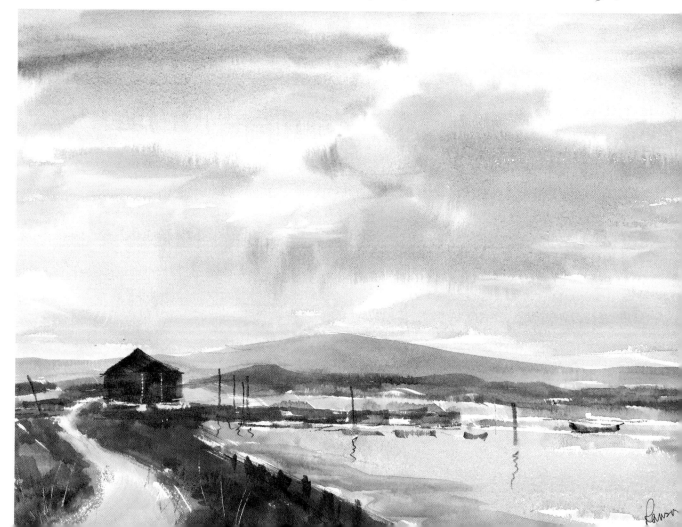

start painting. Timing is very important, as you'll only have about twenty minutes to complete the whole thing. The pure colours are very effective against the strong silhouetted forms but you have to tread a very narrow path to avoid your painting becoming too garish and crude.

One of the most exciting skies to paint is low, fast-moving Nimbus or approaching rain, where the cloud sometimes blends with the horizon, especially over the hills. The wet-into-wet technique is absolutely ideal for this. I use gravity a lot here, as I do with most of my skies, which means that I always tilt my board at a good angle. I find the rich mixture of Paynes

Notice how the clouds appear smaller and closer together as they recede towards the horizon. This seems obvious but is often completely forgotten by beginners who make them all the same size, near or far!

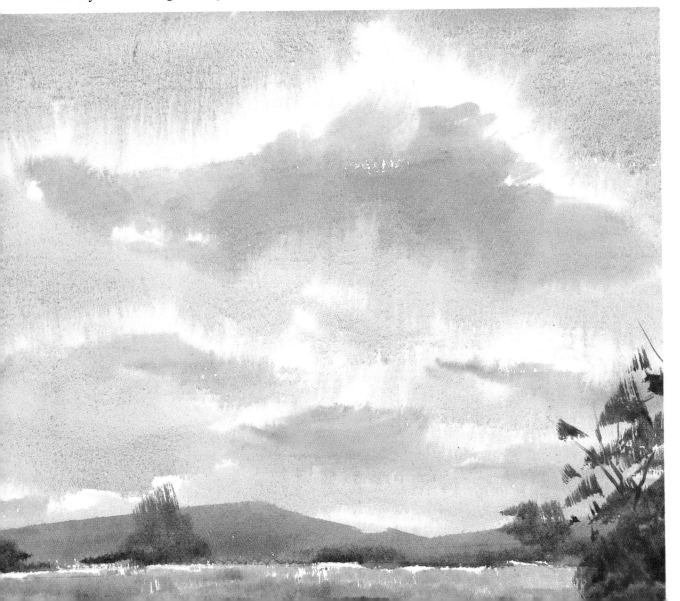

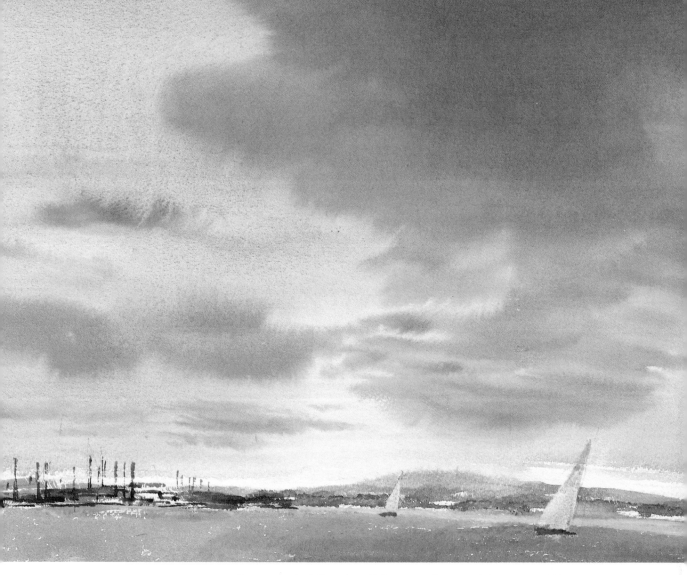

I saw this sky as I crossed over on a ferry from the Isle of Wight. The main clouds seemed to stretch and curve into the distance, which balanced the oil refinery on the left. I painted it from memory at a demo a few hours later.

Grey and Alizarin Crimson dropped into a still wet Raw Sienna wash steeply tilted produces a realistic affect. It's a bit unpredictable, but that's where the third factor – luck – comes in. You'll see examples of Nimbus on pages 7 and 106.

Successful skies do without doubt require a lot of practice. Fortunately, it's easy to find a sky to paint at any time of the year, simply by looking out of the window. Look at it quietly for a few minutes, working out the most interesting features and what sequence of washes you're going to use. Then take up the 'Hake' – draw a deep breath and work quickly and decisively. Maddeningly, you always seem to produce the best skies on odd scraps of paper, rather than on a virgin sheet of paper – it's all psychological!

Finally, remember this important maxim – a complicated landscape needs a simple sky, whereas an elaborate sky calls for a relatively simple, low landscape beneath it.

43

figures in landscapes

You can't go through life avoiding figures in your landscapes –
just because you're afraid of spoiling your pictures. Students
often seem to believe that they need training in life drawing
before they can portray them with confidence – this simply
isn't true.

You'll be able to get away without figures in many of your
pictures, but there are subjects where you'd naturally expect to
find people about. Boat yards, beaches, markets and street
scenes, all of these will look desolate without them. At other
times, figures will add scale to your scene or put life into your
landscapes.

First, learn to keep your figures simple, with the absolute
minimum of strokes. There's a terrible temptation to paint a
figure in very careful detail in an otherwise loose painting, just
because you're unsure of yourself. Don't even think of putting
in facial features, treat them as silhouettes, a dark shape against
a light, or a light shape against a dark background. Let them
also have some action and movement.

The next rule is to keep your heads small and the figures tall
and elegant, and don't bother with feet. Making heads twice as
big as they should be is by far the greatest fault of my students,
and I can't emphasise this too strongly. When I'm putting my
own figures in I indicate the head first, leave a little gap and
then add the body with a few quick strokes of the rigger.

Make sure your figures are an integral part of the scene and
not just put in as an afterthought. They must be in scale with
each other and the buildings near them. Remember, too, when
you're painting a group of people that they lose their individual
silhouettes and become a single unit with a common shadow.

There's really only one sound way of becoming confident
enough with your figures to make them look convincing and
natural, and that is to put a sketch book and soft pencil in your
pocket and take it round with you. Subjects for these quick
impressions are everywhere – people on the pavement can be
sketched from the comfort of your parked car. Don't worry
about any of the details, just put in the movement and think
only in terms of areas of shadow and light and joining them
together. A few hours of this will increase your confidence.

The figures you've then produced are also material to be
dropped into future landscapes. The same rules apply to
animals, the proportions and accurate silhouette being far more
important than any detail.

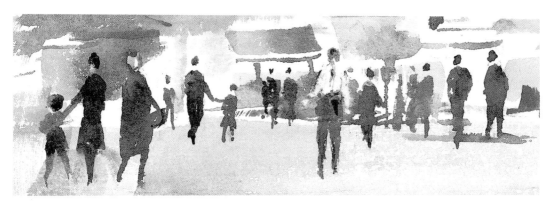

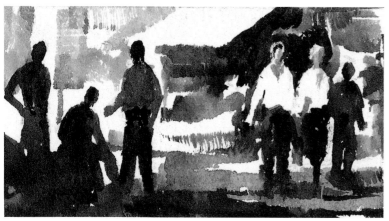

A few imaginary scenes with figures. The main things to remember are small heads and simple silhouettes showing the action rather than detail. Don't forget to counterchange them with their backgrounds.

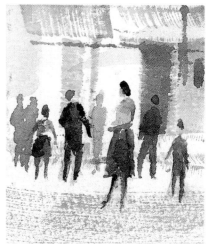

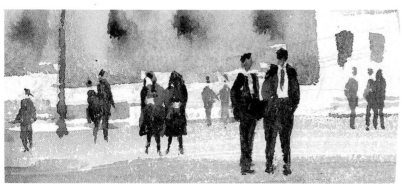

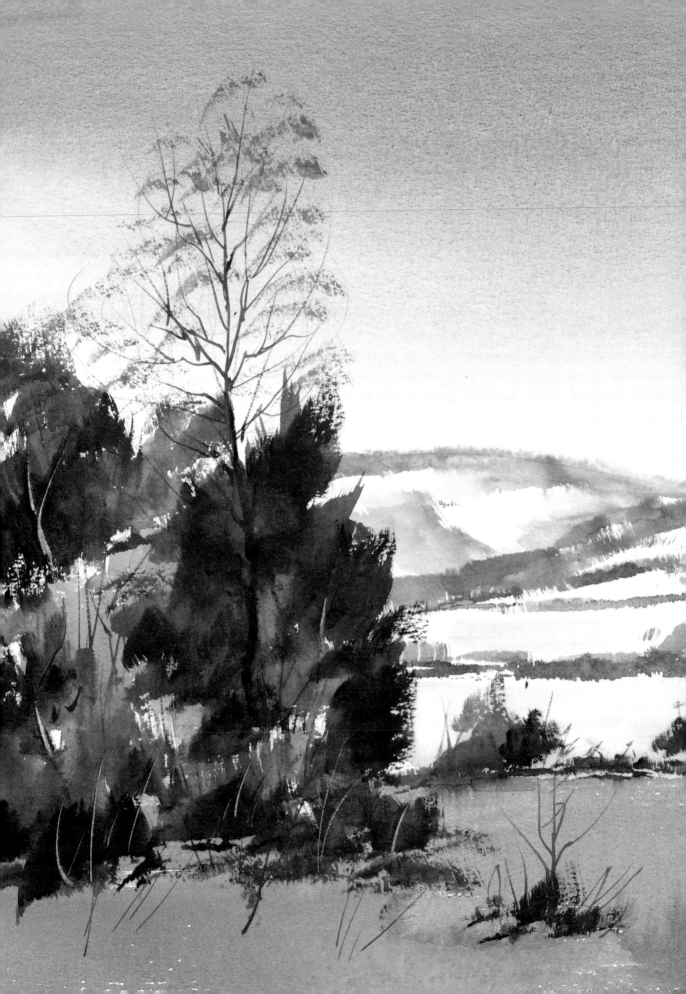

trees and woodland

Opposite
A winter scene using the 'Hake' and the rigger. The distant woods are shown mainly as flat tones whereas strong contrasts are kept to the foreground. The shadow in the front also helps to show up the distant sunlight.

Note how the branches are shown only in the gaps in the foliage, not painted on top, a very common fault with beginners.

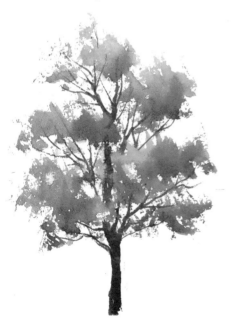

To the landscape artist trees are indispensable – they're a never-ending source of material for picture making. Perhaps they're so familiar to us that we take them for granted. Most of us see them every day, yet most beginners in landscape painting have so little knowledge of them that they end up making trees like green balls on sticks!

Students often think there's some sort of magic formula – I'm often asked, 'How do you do trees?', or trunks, or foliage. It's a pity, but there's nothing so ruthless as the painting of trees to make you realise your own shortcomings. If you're weak in drawing, it shows up immediately. If you're uncertain on colour, your tints will certainly be too green. Unless you're confident in showing vegetation, your foliage will be either spotty or opaque! One finds a lot of students, after a few tentative efforts, try to avoid trees altogether if possible. They prefer to paint something which presents less difficulties, leaping to the premature conclusion that they simply can't do trees!

Even writers of art books are a bit reluctant to impart practical instruction, merely saying to paint trees properly one must study tree form, usually imparting more information about the trees themselves than the techniques for producing them.

I hope the foregoing hasn't depressed you, but I've still got to agree with the others – that there's absolutely no short-cut to learning the basic anatomy of trees. You'll never be able to paint them convincingly in watercolour, until you've filled a few sketch books with pencil drawings of all sorts of trees.

First, you should become familiar with the different types of trees. It's better to begin this in the winter months when their basic shapes and outlines show. Unless you have a good idea of the fundamental structure you'll never draw them properly. It's like doing life-drawing where you need to have a knowledge of anatomy before you draw the fully clothed figure.

Just imagine you're standing in front of a tree. Look at the growth pattern, note how the roots, trunk, branches and twigs grow. Think of the overall shape as a silhouette, remembering always that the growth pattern is inside the tree. Have a look at the trunk, it's thickness, texture and how the lower branches radiate from it. If it's summer, do the major branches show through the sky-holes? Do the twigs extend beyond the edges of the foliage?

Let's consider the two main types of tree – deciduous and coniferous. Deciduous trees shed their leaves, changing their appearance from season to season, each shape bringing a new challenge to the painter.

One of the most common mistakes the student makes is trying to paint the foliage leaf by leaf, whereas you don't actually see the leaves with your eyes. You see units of colour masses. It's only your mind that tells you they're leaves. Try screwing your eyes up when you look at it – it's a three-dimensional object, and must be painted thus to become credible. It's not a flat thing – it's branches spread, not only from side to side, they also come towards you and move away.

There's a very common tendency for students to paint winter trees like spread-out hands! Of course, in winter, the deciduous trees show their character more clearly, once the branches are no longer hidden from view by the leaves. When you're painting a winter tree, take the branches to a certain point with a rigger, but don't try to indicate every twig at the end. You'll get a much better impression of fine twigs by using very dry brushstrokes with the 'Hake'.

A common fault among students is to paint 'conventional' branches on top of the foliage, even though they can't actually see them, the branches are behind the foliage, feeding into it! It's just lack of observation.

Autumn is a dangerous time for tree-painters, it usually brings forth a rush of garish paintings by students. The trouble is that they make *all* the colour too brilliant, with no contrast, which seems to cancel itself out and what may be breathtaking in nature is just gawdy in a picture. As for myself, when I'm painting autumn scenes I prefer to do them on grey days, rather than in sunshine, toning down some of those bright reds and oranges, giving the picture a bit more subtlety. In fact I like to wait until early November when some of the leaves have fallen and there's some bare branches and twigs to add variety to the scene.

Now to the coniferous trees – those that retain their foliage throughout the year, they have needle-like leaves that stay fresh all year round. Although these trees don't change much, their environment certainly does, and they stand out much more in the winter, especially in the snow, than when nestling in the middle of a green wood. Basically, all coniferous trees have a central trunk with branches protruding sideways all around at a

sharp angle. Also they change colour with age, young trees will have very fresh, bright green foliage while an older specimen, of the same species, will be much darker.

It's one thing to learn the characteristics of the different trees, and learning to draw them, but you also need to know about how to introduce them into your pictures. One factor, often forgotten, is the proper lighting of your trees. As a general rule side-lighting is always preferable to painting with the light behind you, or painting into the sun – it means you get better shadows. The shadows can enrich foregrounds and give depth and mystery to foliage, playing an important part in directing the eye and giving solidity to your trees. They also make interesting patterns and accent the textures of rocks and

A sunlit, misty woodland scene with wet-into-wet in the background. I gradually added stronger and richer colour as I approached the foreground. The left hand tree was finally painted with the rigger, and the dry brush leaves indicated with the side of the 'Hake'.

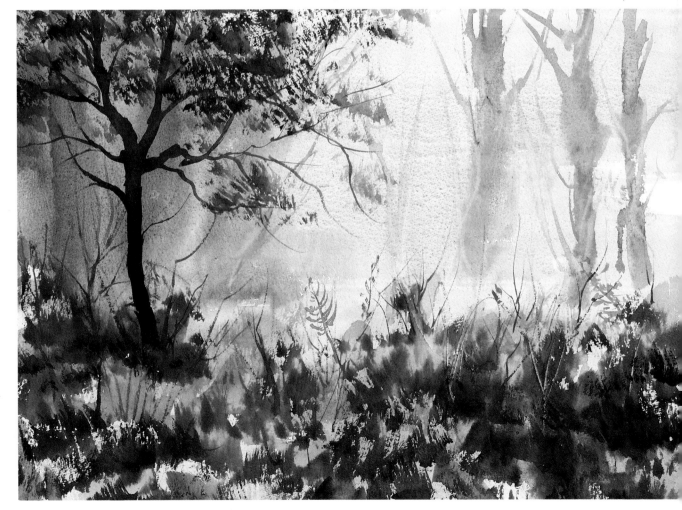

grasses, and the contours of the ground surrounding them. Many's the painting that's be brought together with a strong foreground shadow.

If you want to indicate the size and height of a tree you can use such things as a hedge, fence, barn or even a figure.

In a picture where you've got trees in a group formation, every tree must be exaggerated or repressed in order to obtain the best effect as a whole. The larger the number of trees in the group, and the further away they get, the less details in the construction of foliage you'll need to put in. Trees in woodland are massed together and must be painted that way, they give up their individuality completely to the group. Again it helps if you screw your eyes up to eliminate the detail. Just paint the patterns you see, the lights first, then the darks. Even further away, a large wood on the horizon should be painted with just one stroke of the brush.

I really enjoy painting woodland scenes, which I feel lend themselves very well to loose, free watercolour. The technique I use is to start at the very back of the woods, with a fairly bluish-green, and indicate some of the far distant trunks, wet-into-wet with a rigger. Then I gradually come forward, putting in darker and richer colours as the paper is drying, so the nearer trees become sharper and more specific, finishing up in the foreground with more textures containing stronger, richer colour. I try to convey the depth of the scene by contrasting the foreground sharpness with the softness in the far distance.

To sum up then, once you've learnt to paint trees convincingly, you've overcome a big hurdle. In general, look long and hard before you paint them – simplify the shapes and colours – add a small amount of characteristic detail – then stop!

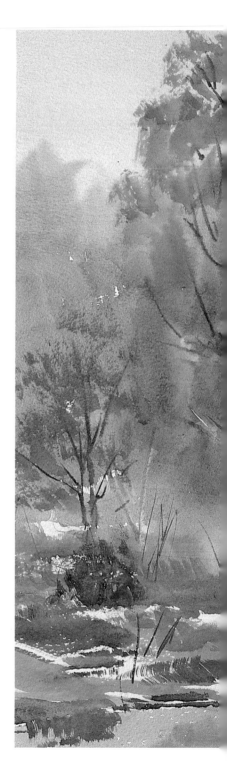

An imaginary woodland scene painted as a demo. I worked strictly from the back to the front of the scene, with wet-into-wet in the distance and dry brush work in the foreground.

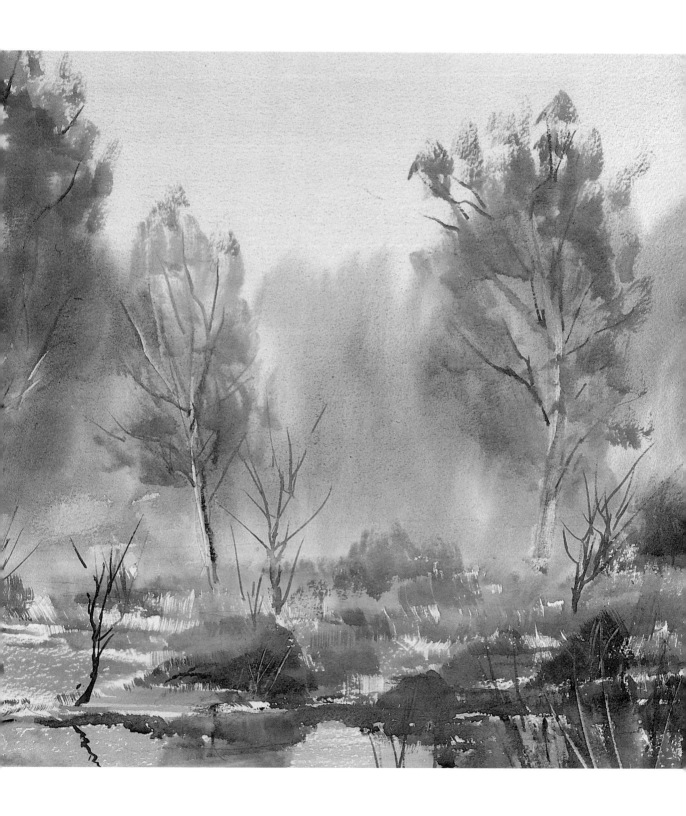

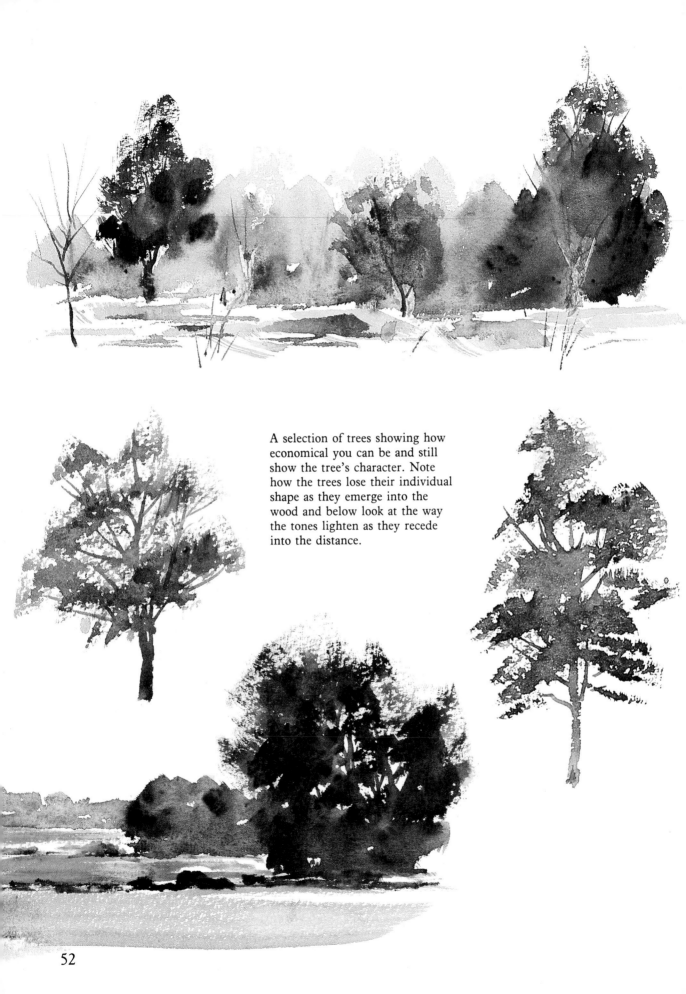

A selection of trees showing how economical you can be and still show the tree's character. Note how the trees lose their individual shape as they emerge into the wood and below look at the way the tones lighten as they recede into the distance.

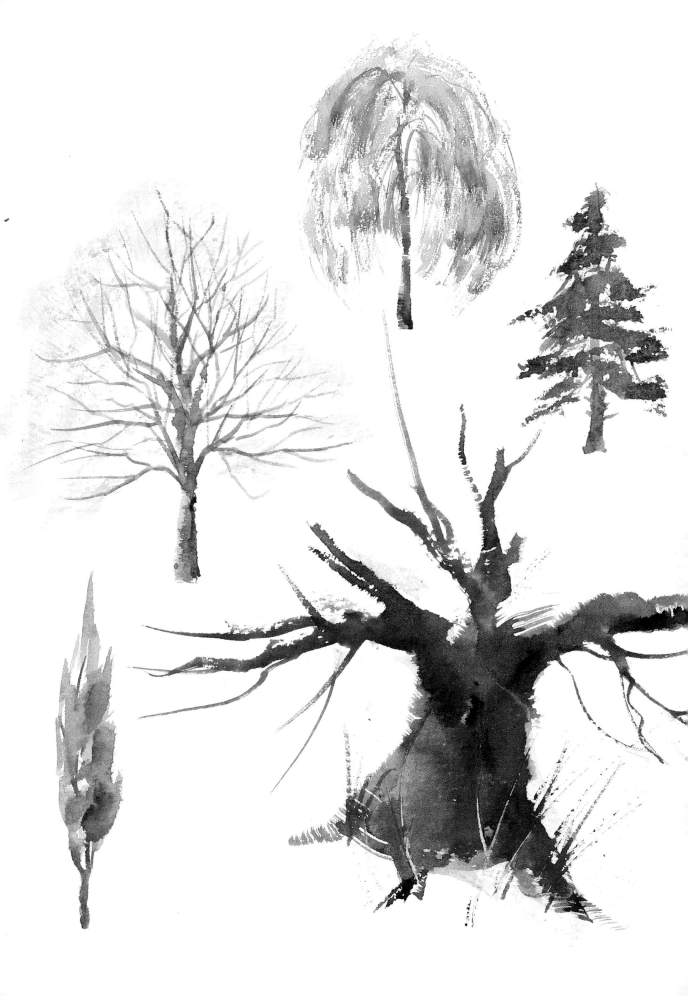

rivers and streams

There can be few experiences in life more pleasurable than the anticipation felt as you set your easel up by a winding stream, a brook, or a rushing waterfall on a calm sunny morning. Practically any aspect of water in landscape has a hypnotic appeal for me – almost like a drug. If you were to walk around one of my one-man exhibitions, you'd probably find seventy per cent of the pictures contained stretches of water in some form or another!

The ability to paint this water convincingly should be well within the scope of every student, but so often it's very poorly depicted – usually through various misconceptions. Many beginners, somehow, believe all they've got to do is to depict it entirely with horizontal streaks, fondly imagining they're putting in ripples – personally I feel ripples are death to watercolour!

While I'm talking about faults, I said in my first book that probably the worst mistakes students make were to make rivers flow uphill and to tip them over as they go round a bend. In the two years since then – nothing's changed – most of them still do it! The secret is to look at the river in front of you, as a flat shape. As you're drawing it, compare it, critically, with what you've got on your paper, letting your eye go backwards and forwards, from the river to the paper.

Having got over my 'grumbles', let's start looking at the various surfaces of rivers. First, calm water, when perfectly smooth, reflects the sky just like a mirror. If disturbed by a slight breeze or a current, the surface becomes textured and the reflections soften, and lengthen. As with many other things mentioned in this book, simplification is the answer. Do the absolute minimum to depict a river, remembering that the water always tones down what it reflects. Colours are less intense, darks become lighter and lights a little darker.

Students are always amazed at how little you need to do when painting a river to make it look authentic. Whole stretches can be left just as a flat wash, but the objects surrounding the river must be accurately observed and put in properly. The usual mistake is to change the shape of a tree entirely when it's reflected, or to move the reflections sideways, worst still, to forget to reflect some objects at all! Many of these faults occur on every course. The surface of the water is seldom completely smooth and you get small areas where a light breeze disturbs the surface, you can get this effect

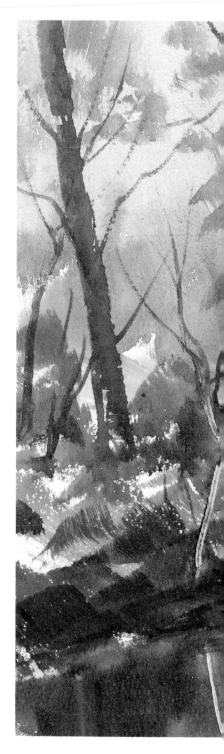

A very loose painting of a
woodland scene. Note the
counterchanging of the right hand
bush against the pale, sunlit
distant woods.

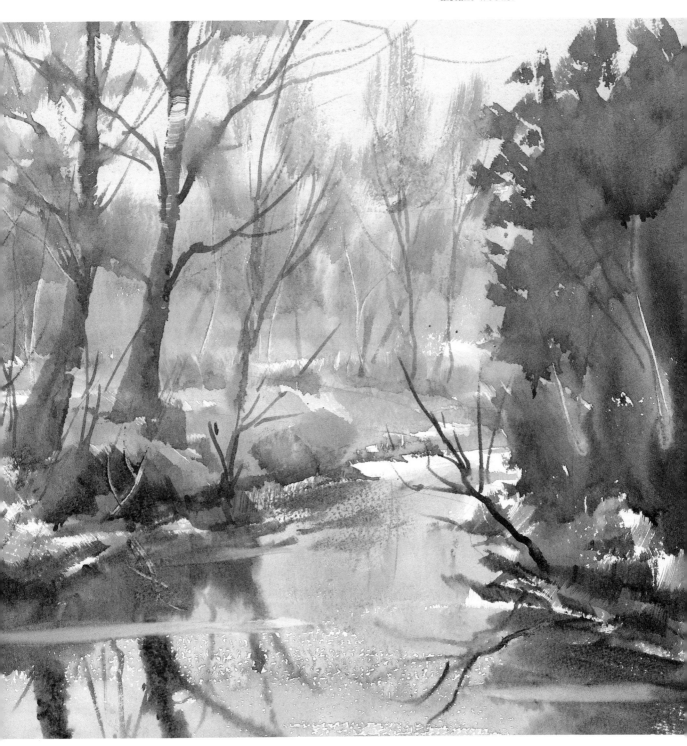

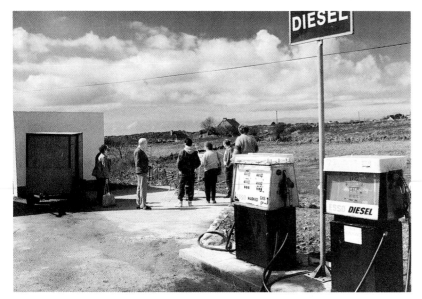

Running a course in Galway in Ireland, my students and I came across this unpromising filling station, but looking over the back produced the scene opposite in a 15 minute demo. Don't spend your life looking for the perfect ready-made scene, the trick is to make the most of what you've got in front of you.

by putting a quick sweep of a dry 'Hake' across the still damp reflection. It's always more effective against a darker section of the river, for example, the reflections of a dark tree.

Water carried down to the bottom of a picture can look as if its falling out! You can often counteract this by putting a darker tone across the lower part. The trick I use for this is to wait until the river has been completed and is dry, I then turn the whole painting upside down and put a quick wash of clear water over the whole river surface, then a dark wash across what is then the top of the river, allowing it to graduate down to nothing towards the back of the river. Once this is dry you turn the picture upright again and you get a good effect of distance.

My own method of treating a river is to leave it until last, after everything else has been put in. I then know exactly where my reflections should go. I paint the river more or less the same colour as the sky, which seems obvious, but believe me, I've seen yellowy/grey skies, with blue rivers! While the whole wash is still damp, I drop my reflections in using strong colour to compensate for the dampness already on the paper, the strokes being vertical, *not* horizontal. If I do decide to put a white streak of disturbed water, I keep it to one, or at most two, not ten, as sometimes happens on students work. They often have difficulty where the river bank meets the water, this shouldn't be indicated as a hard line, but merely suggested at different spots so that the eye can join these areas together.

You can introduce things such as posts, or even reeds which can be reflected below with wriggly lines – again don't overdo this. Most reflections are almost exactly the same as they appear above the water, an exception being the arch of a bridge, here one sees much more of the underside in the reflection than you do when looking at the bridge itself. Notice this on page 59.

Although the colour of the water is influenced by what is reflected on its surface, in very shallow water the bed itself will

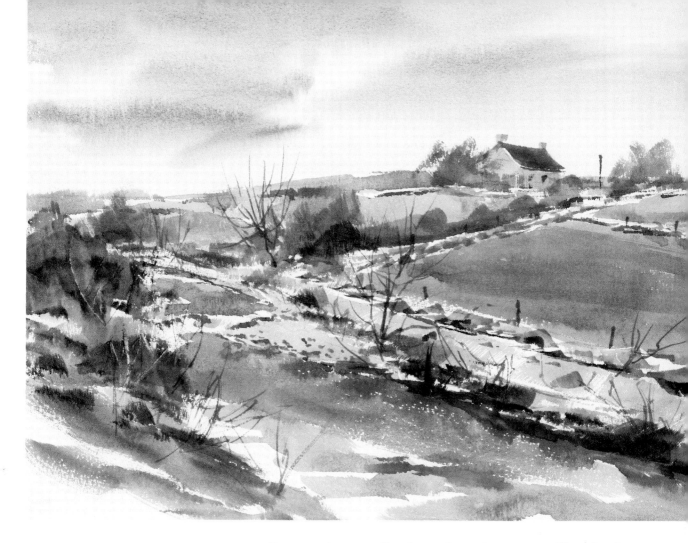

contribute to the overall colour. A sandy stream will make the water appear rather paler, whereas a muddy bed will make the water dark, and the reflections will not have any definite colour.

Whilst not exactly rivers, I find flooded fields in winter which become enormous lakes, provide very exciting subjects for watercolour. They often may include such interesting things as partly opened farm gates and fence posts, which when reflected in the water provide fascinating patterns. Another thing which you should watch out for is puddles. A country lane or track after it has rained can be great fun as a subject, but again you've got to observe carefully, before you actually start painting. Contrast the value of puddles with their immediate surroundings. For example if the ground next to the puddle is dark, leave the puddle almost white, showing an extremely dark reflection in it. Leave the very edge of the puddle which has any value of its own pure white, a quick flick with a sharp razor blade after the painting's dry will do this. When the puddle is dark, it's obviously reflecting something, so remember, if there's a reflection, there must be a source.

When you're painting lakes and larger stretches of water, don't neglect the cloud shadows, these will greatly help to create interest on an otherwise plain surface. Even with a river,

A fast moving river in Galway. I made a lot of use of the white paper with a few quick strokes of the 'Hake' to indicate the general direction of the flow. Note the side lighting to show the shape of the rocks.

you'll find that a busy cumulus covered sky will affect and vary the surface colour of the water.

Let's turn to faster moving rivers with rapids and white water. When you first sit down and look at this it may seem impossible to paint, but try screwing your eyes up and you'll begin to see a basic pattern emerging. Water in a stream tumbles in some parts and flows in others, and you've got to watch these movements very carefully for quite a long time before you paint a generalisation of this movement. Even your brushstroke should follow the action of the water – we're back

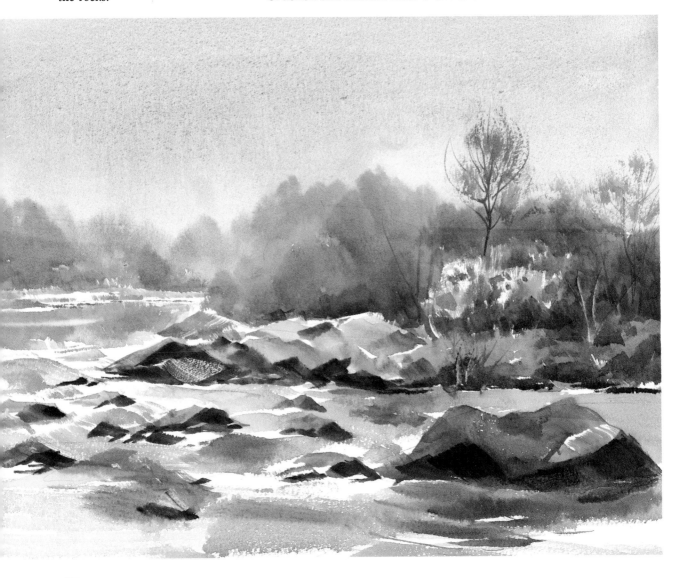

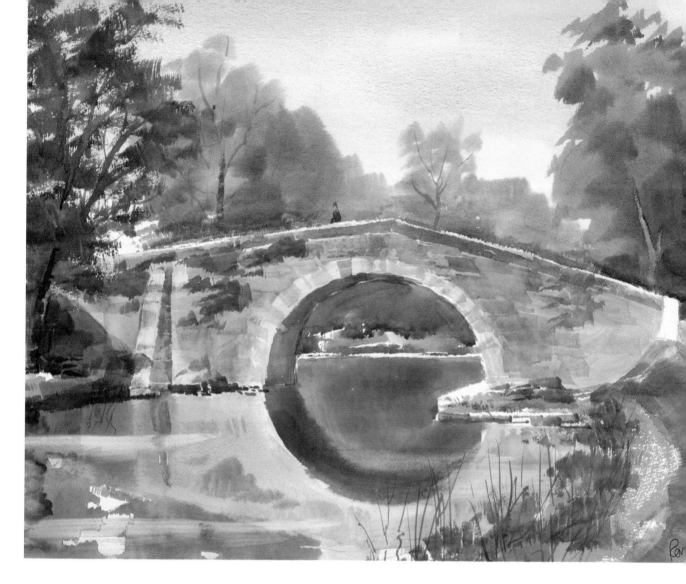

This was painted as a demo during a hilarious painting trip down the Canal du Midi, in France with ten students. Notice how one sees the underneath of the arch in the reflection, but not in the bridge itself.

to simplification! Rushing water looks much better when its understated and the absence of detail gives the impression of rapid movement. I've tried to do this in the picture on page 94, reducing the surface to a simple pattern.

When painting streams or brooks the mistake often made by students is to try and take in too much, so just settle for two or three rocks in turbulent water or a bit of the bank with little or no landscape and water that's quiet and slow moving. Where foam swirls around the rocks in a mountain stream it's often best shown by leaving the pure white paper. In general, use brushstrokes that follow the action or direction taken by the flowing water.

It might be appropriate, here, to talk about the rocks themselves. Students so often think there's some formula for drawing and painting them – there isn't! Just remember that rocks are solid. They have bulk and weight. As the top of the rock faces the sky it gets the most light and the sides are darker. The part of the rock that faces away from the light source is darker still, so it's always very important to find out, first, where the light source is coming from.

59

boats and harbours

Those painters who say, defiantly, that they can't draw boats and avoid nautical subjects are missing out tremendously. Wherever boats are, there are fascinating possibilities for paintings and a unique atmosphere in complete contrast with any other surroundings. To show you an example, imagine a busy city street with bustle, noise and haste – all most discouraging to artistic activity, but go down a few steps on to a canal bank below – a completely different world opens up! A quiet tow-path, a patient fisherman, a slow 'chug-chug' of a working barge, interesting bridges, a woman hanging out washing on a moored barge, one can hardly wait to start painting! Do you see what I mean?

I recently took a party of ten students on a barge, down the *Canal Du Midi,* in the South of France for a fortnight's cruise, painting and sketching all the way, except when we were getting ourselves through locks, or drinking wine! It was a fascinating trip with wonderful comradeship, but the most memorable feature was the absolute surfeit of paintable subjects around every bend.

There are lots of books by marine painters describing boats, boat construction and equipment in great detail – very interesting these are too, but you don't have to be a marine expert to draw a boat, any more than you have to be an architect to paint a street scene. What you do need is commonsense and a lot of practice! So we're back to that sketch

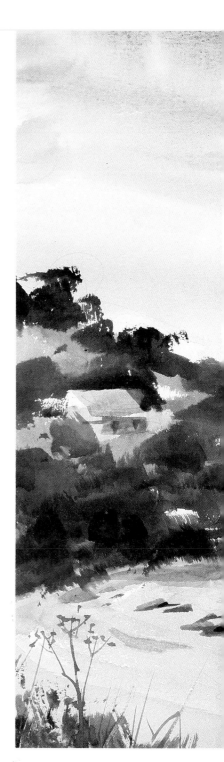

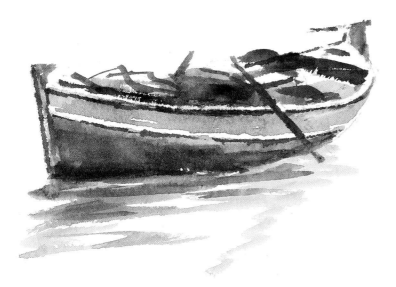

A demo done on another painting
holiday on the island of Herme,
the sky is a simple one with just a
few wisps of Cirrus. Note how the
roofs on the left are counter-
changed against the dark trees.

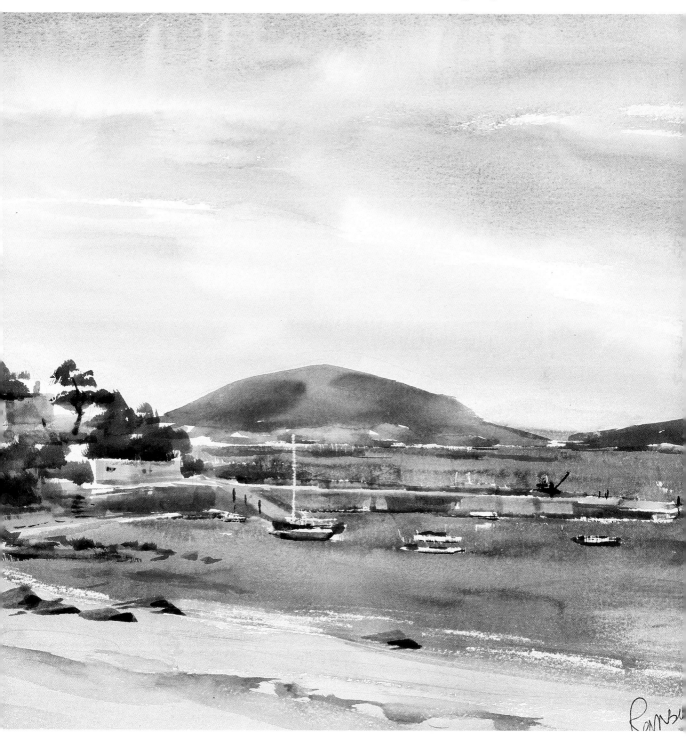

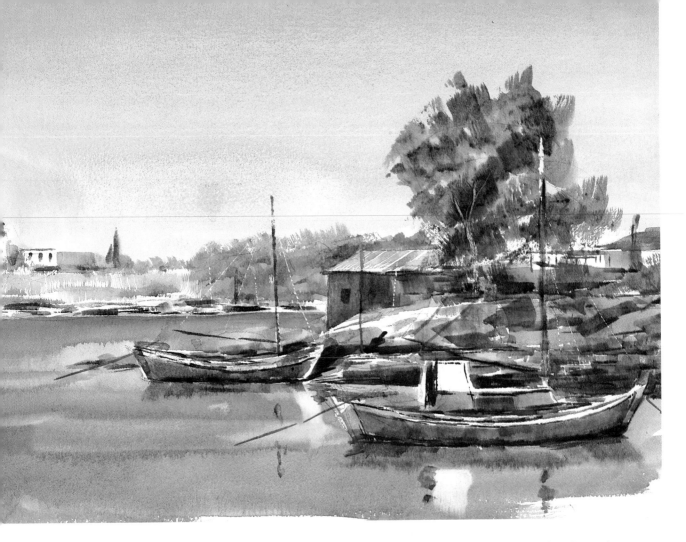

book again! Make sketches of all kinds of boats – remembering always that good drawing is based on good observation.

For the artist, harbours and marinas provide scenes of constant bustle and activity. There's always something happening all year round, a wealth of ever-changing form, light and colour in ever-varying weather conditions, ranging from bright clear sun, making the water sparkle, to murky fog with its interesting grey silhouettes. The picture possibilities are infinite.

Overhead, the sky is constantly disturbed by the graceful wings of white gulls. When the tide is out, we see the green scummed masonry and the harbour bottom glistens with wet seaweed and slimy mud, exposing the rocks full of deep, rich colour. There are reflections everywhere repeating the forms and colours. I'm not trying, in this chapter, to provide you with a ready-made formula for drawing and painting boats – there are plenty of other books on that! What I aim to do is to 'whet' your appetite and get you out on that harbour wall or in a boatyard to see and smell the atmosphere.

You ladies are not off the hook, either, though many of you seem to think that you should automatically be excused boats. However, one of the best books on the subject, *Painting and Drawing Boats* has been written by a lady I know – Moira

This was painted as a demo on a trip to the Greek island of Spetses. It was a busy harbour with lots of boatyards making traditional boats by hand, eye and skill!

Huntley, so you've absolutely no excuse now!

One thing I'm always being asked about is the tone of reflections in still water. Everyone's heard some rule about this, but promptly forgotten it. The basic thing to remember is that light tones reflect slightly darker in water, and dark tones slightly lighter, making the tone values in the water less contrasting, making the reality appear sharper in comparison.

Just like the trees in the last chapter, we must get to know the basic construction of boats to make them look right, and convince the viewer that the craft is really seaworthy. The keel is the backbone of a boat and corresponds to the trunk of a tree, so just as I said in the last chapter, when I talked about winter

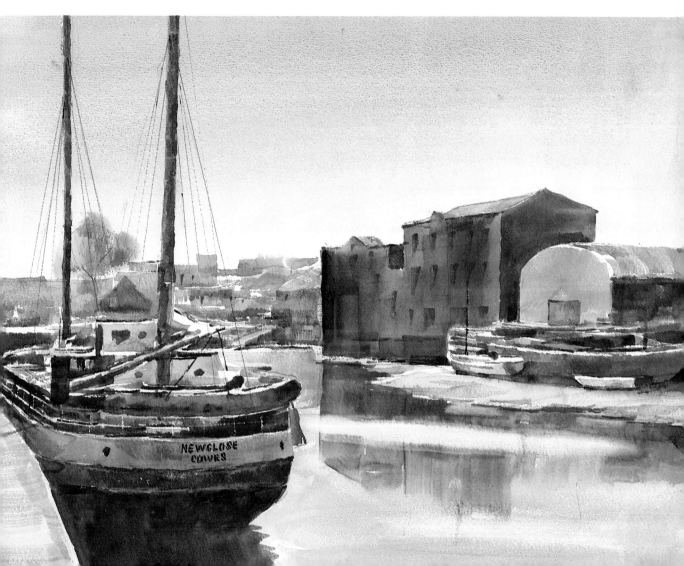

A river scene on the Isle of Wight. The distant town has been merely hinted at, and the warehouses simplified. Note too the various counterchanges.

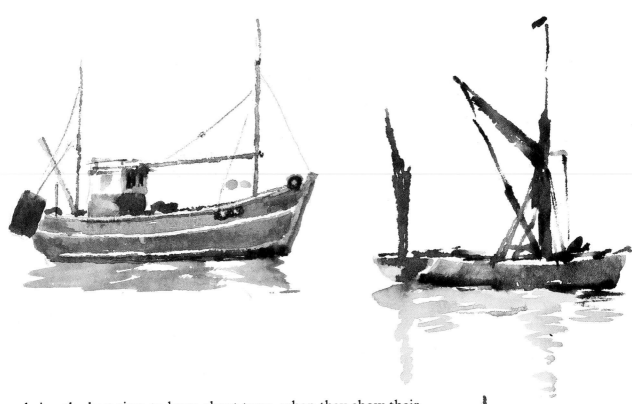

being the best time to learn about trees, when they show their real structure, uncluttered by leaves. This same principle applies to boats at low-tide or in the winter, when they're stored in yards. You can see, draw and understand much more of their construction. Afterwards, the knowledge you gain will show up even when the boats are in the water and partly covered.

One problem I've solved is that of indicating a distant white sail or a group of white masts after the rest of the painting is finished, and dry. It involves two sheets of paper, a paint rag and some spit! With a small, white distant yacht, sometimes very useful as a help in composition, I overlap two pieces of paper at an angle and wipe the area between them with one finger inside a moistened paint rag. Take the paper away and hey presto – a yacht! If you want to reflect the sail in the water, just repeat this procedure upside down. Masts are the same procedure, but the paper sheets are laid parallel with only a tiny gap between them, depending on the width of the mast required. Try experimenting on some bits of scrap paper!

Now let's look at some of the main faults of students which occur mostly through lack of observation. Usually, they show the hull too far out of the water, making it look unstable. With a sailing boat they make the mast too short, as a rule it should be longer than the length of the boat itself. The mast should also be slightly forward of the centre, allowing for the big mainsail at the back and the smaller jib at the front. Stumpy masts in the centre of a boat look very amateurish, even childish, no matter how small they're painted.

Rigging too, should be put in with the utmost discretion,

A few sketches of various boats done mostly with a 1-inch flat brush, which forces you to simplify the tones and shapes.

64

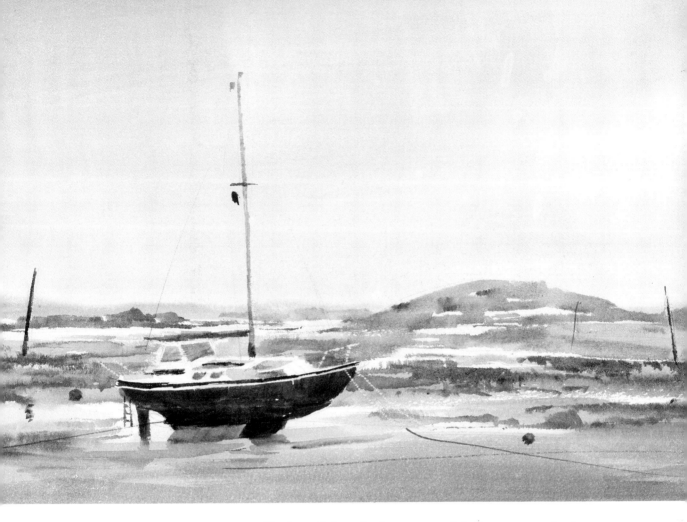

Another demonstration on the island of Herme. This was the second attempt, the first being ruined by spots of rain. There's a threatening wet-into-wet sky contrasting with the textured beach and grounded yacht. The white ropes were flicked in with a Stanley knife blade.

usually just 'hinted' close to, and left out completely at any distance. Some beginners seem to be obsessed with rigging, and yet lack the skill to indicate it properly. I usually put in lightly, perhaps only one in ten of the ropes with a quick flick of the rigger, or if it's against a dark background, a light scratch with the blade of a craft knife.

When we're painting these marine subjects 'fast and loose', what we should be doing, is to make sure that our picture is designed properly, with pattern and values arranged to give interest, unity and balance. Try to avoid sentimental type pictures, but look instead for chunky shapes and varied colour, texture and pattern. When you're faced with a scene of complex confusion, with lots of activity all around, you'll need to simplify dramatically – because there's always much more in front of you than actually needed in the painting. Perhaps make one boat dominant, allowing the others of less importance to support it visually. Remember it's much more important to get the mood of the scene and the proportions of the boat right, rather than too much detail. Provide an eye path that leads quickly to the main focal point. Then search for overlapping elements with counterchanging (there's that word again!) darks and light tones to give vitality to your picture. Forget about the details at this point, after you've put in the main shapes you'll be surprised how little detail you need.

65

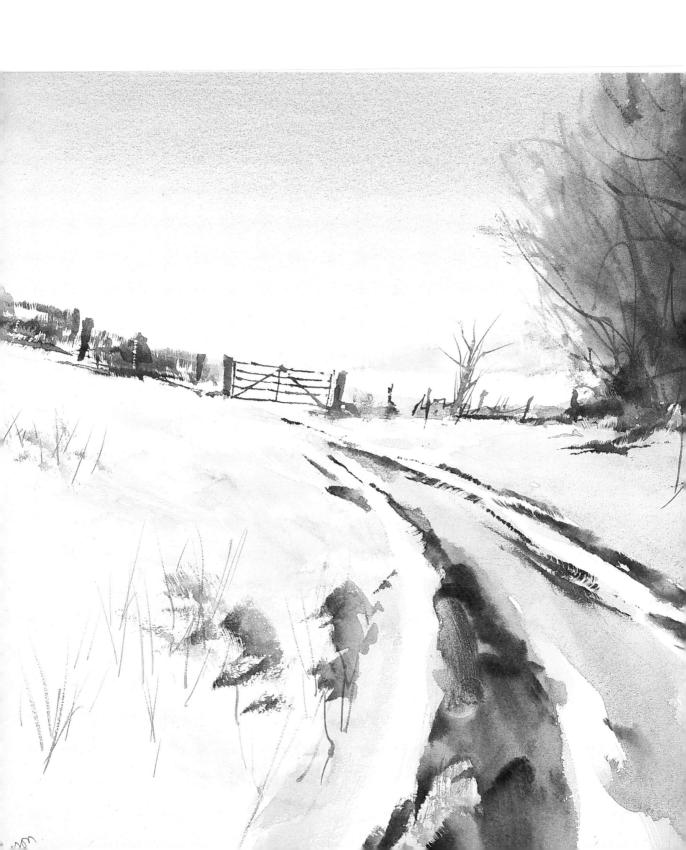

snow scenes

Snow scenes are deceptive. They tend to look easy but to depict them properly you must use keen observation. Be wary of turning them into pretty 'Christmas Card' pictures. They should be very well-designed beforehand because the composition is even more important than in a summer scene. Work out the picture carefully in terms of light and dark pattern by producing tonal sketches before you attempt your finished painting, not letting light and dark areas be equal in size and importance. One or the other must be dominant.

Don't get the idea that snow is pure white either – it isn't! White snow reflects other hues around it more vividly than any other colour. To get colour unity in a snow scene, you must model the snow using the most dominant colour in your painting. For example, a warm grey cloud will mean that the same warm grey should be used for the shading of your snow. However, a rich green forest would tint your snow with a touch of green. With a clear sky, the warm glow of reflected sunlight gives the snow a yellow tint which is pale at midday and more golden or even orange at sunrise or sunset. The shadows, where the sun doesn't reach, are coloured by the blueness of the sky. The subtle contrast between the warm and cool colour intensifies both of them. The colour on sunlit buildings and trees will reflect in the snow, especially in the shadows – it's all very subtle stuff! This is perhaps even more so in an overcast scene, where there's a great variety of warm and cool greys. I find I can get most of these greys by using various proportions of Burnt Umber and Ultramarine – more brown for warmth – more blue for coolness.

Shadows in snow scenes are very exciting, but you must plan them carefully beforehand. Remember, they will actually describe the contour of the surface they're falling over, curves, ruts and all.

Work out in your mind what you're going to do, take a deep breath and put in shadows light and fast! Then leave them strictly alone! Don't try to touch them up afterwards or they'll lose their transparent freshness. Ultramarine with a touch of light red is a good colour mixture.

A very loose painting. What attracted me was the way the cart tracks took the eye to the tiny gate – the focal point of the picture.

While the texture of the snow is usually smooth, it's often broken up where the grass and earth show through. I use the rigger for the grass, and a bit of dry brush 'Hake' for the earth.

For the winter scenes I usually restrict myself to five colours: Raw Sienna, Burnt Umber, Light Red, Ultramarine and Paynes Grey.

Winter trees are a delight to paint, one really sees their anatomy unhindered by leaves. The fine lace pattern of branches and twigs form a beautiful contrast to the smooth plains of the snow. The rigger really comes into its own here,

I must admit this was a 15 minute indoor demo done while my students had their morning coffee – not a minute is wasted on my courses! Done entirely with the 'Hake' and the rigger.

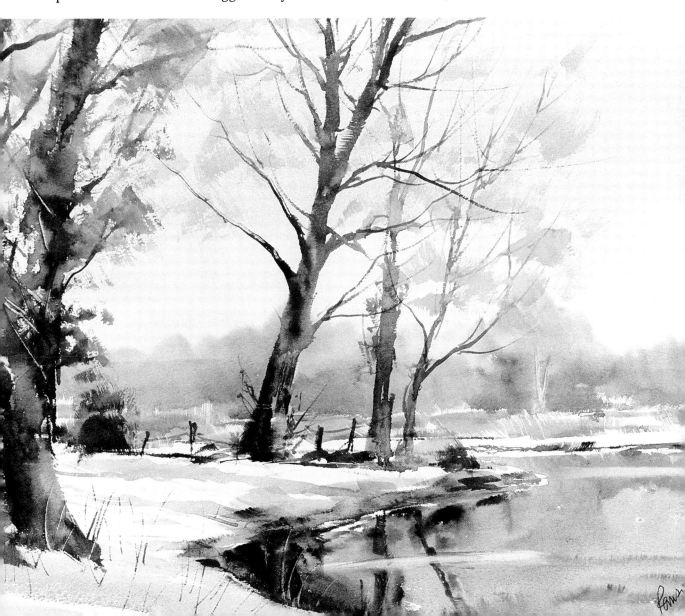

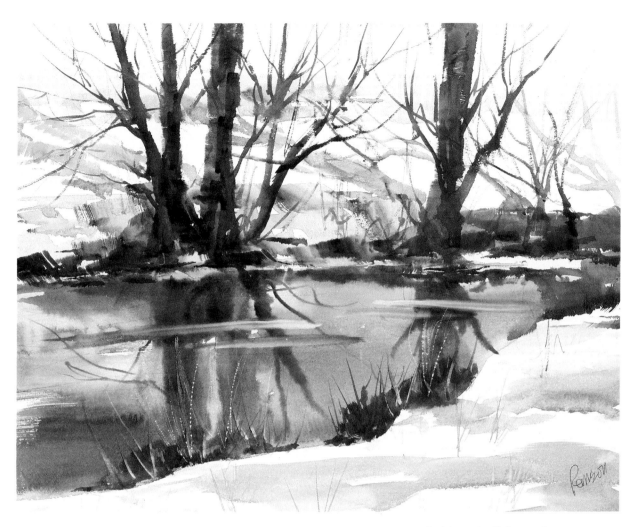

What I liked about this scene was the strong contrast between the dark rich tones of the stream surrounded by the white snow and the calligraphy of the bare trees and their shadows.

but I often find students are afraid to build up the structure properly – they paint a trunk, add a few thin branches then give up. So much beauty deserves a little more observation and patience. Do spend time just looking at your tree before you take up your brush.

It may sound obvious, but a single light source only casts one shadow and that moves in the opposite direction to the light source, so if the light comes from the left side of a tree, the cast shadow is directly to the right. If you forget that, things can look confusing. Incidentally, if you paint in the early morning or late afternoon the shadows will be at their strongest and the picture will be more dramatic.

Of course working on the spot with watercolour in the snow can have its problems, so first try to choose a sheltered spot. If it's freezing a few drops of glycerine added to your water will help, but not too much, or it won't dry. Do at least try it, even if you only stay for a quick sketch. The dead stillness and silence experienced by working alone in the snow, gives you a sense of peace that you can't experience anywhere else.

buildings and streets

The very idea of painting buildings in a 'fast and loose' fashion seems fraught with difficulty. Surely you have to make careful drawings and what about all the perspective and the detail required? The fact is however, that you can produce authentic looking buildings in a free manner, as easily as all the other subjects in this book. A high proportion of ordinary landscape paintings do have buildings in them, whether it's a lonely moorland with a single cottage in the distance, or a harbour scene with houses in the background. A badly portrayed, overworked building can really let down an otherwise fresh and lively painting.

Let's start with perspective – the word that seems to strike fear into the hearts of so many students. Although whole books have been written about it, the main principles can be broken down into three simple rules. Firstly, objects in a landscape appear to diminish in size as they recede from the viewer. Secondly, the horizon is always at the eye-level of the viewer. Thirdly, parallel lines on such things as buildings tend to converge in the distance. The rest is mainly commonsense and observation, here again, observation is all important, together with continuous comparison between what's in front of you and what you've actually got on the paper.

Even before you do this though – you should have made a little tonal sketch to establish a good abstract pattern of your group of buildings. You should choose a few main shapes and organise the main areas of light and shade to use as part of your

Opposite
This was a village scene on a course I ran in Callabria in Italy, with lots of interesting textures and colour in the walls.

A simple cottage in Galway counterchanged by dark trees and foreground textures. The roof tiles were indicated with the 1-inch flat brush.

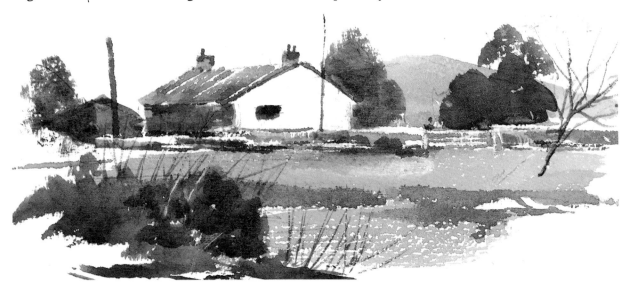

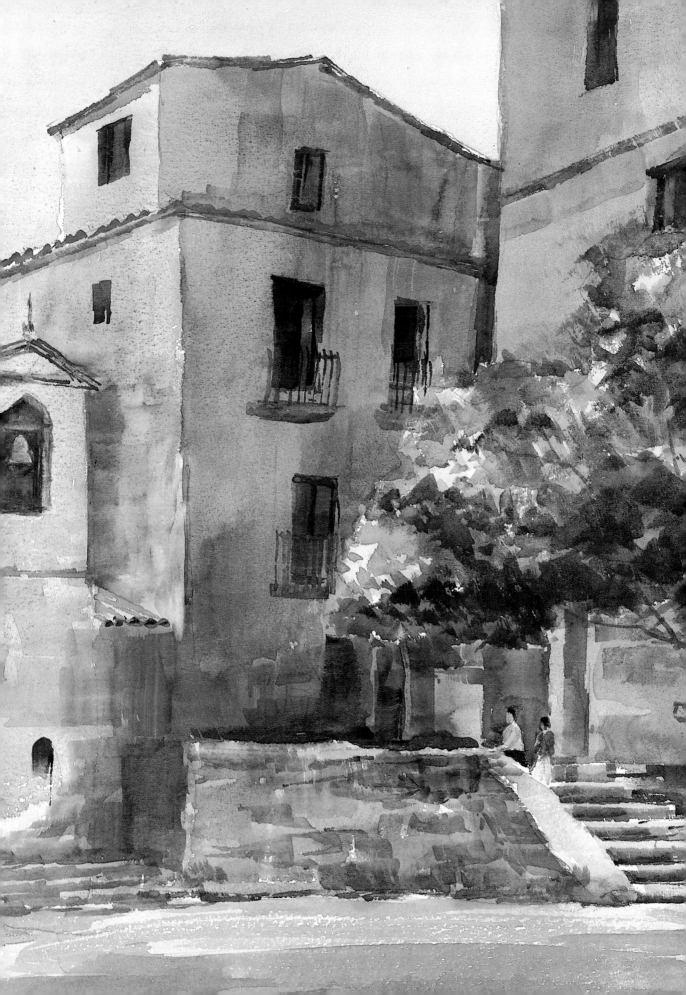

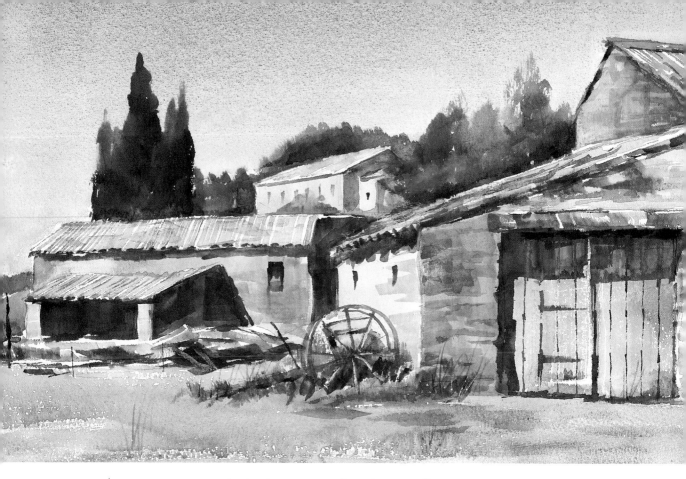

picture composition. Don't hesitate to make changes from nature, if it will help your design, such as moving a large, cast shadow across a road and buildings if you feel it will improve things. You'll usually find the long shadows created in the early morning and late afternoon, are a big help in establishing this abstract pattern. All this is much more important to producing a good picture, than worrying about details.

Once you've got the structure of the picture right, it's amazing how little detail you'll need. Students don't realise this however, and their main trouble is always overworking – stone walls, tiles and windows are painstakingly painted in, rather than being merely suggested. For example, just indicating the stone in about one tenth of a wall leaving the rest of it plain, will enable the viewer to understand its whole construction. Windows, too, are a problem. A beginner often tries to laboriously draw in each individual pane of glass, rather than showing it as a dark shape. If you really want to go further, you can always give a couple of quick flicks with a razor blade after it's dry – this will break the shape up.

Perhaps the most common impression one gets from students' paintings of buildings is one of timidity, flatness and a washed out quality, with not enough contrast and counterchange. They show perhaps, the corner of a house with two sides exactly equal in tone. The only way they can indicate the corner itself is with a line, or as I call it 'wire'. 'It was like that' they protest, but if so, they had chosen the wrong time of day to paint that particular building, or they hadn't used their

A farmyard we discovered during a painting course in Provence, France, giving plenty of opportunities for textures.

72

prerogative of deliberately changing the tones.

With regard to distant buildings, it's amazing how little you need to do – a few strokes with a flat brush to indicate the roofs, counterchanging with white walls and a few windows (not all of them!) and you've got a Greek village. The secret is understatement and simplicity. The further away – the less detail.

If you're merely using a building as part of your landscape, perhaps as the centre of interest, put it in the middle distance so that the eye of the viewer can move easily to it, after entering the landscape. In this case, avoid making it too large and placing it smack in the middle of your paper.

To sum up, to give your buildings a feeling of 'solidity' and the illusion of reality you must keep the light direction in mind, and make use of the light and shade to model the form of the building.

A scene on the Grand Canal in Venice, showing the very loose treatment of architecture. I went to Venice recently for two days and took over 250 photographs there! It's a fantastic place!

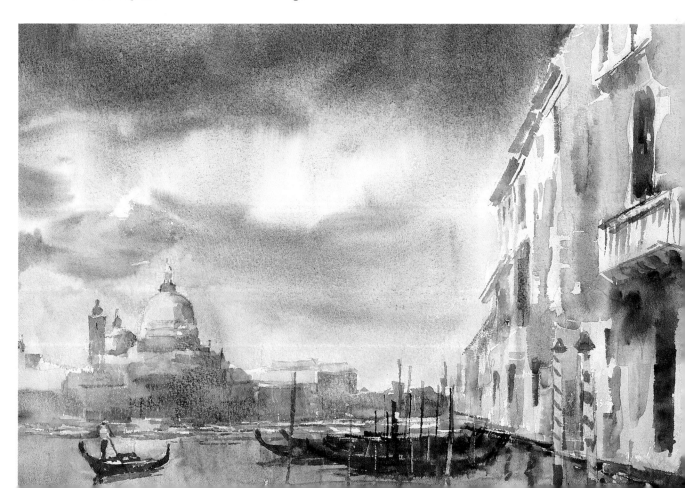

using photography properly

My faithful SLR camera with its normal lens.

Photography used badly is a menace – if it's used too literally it can destroy any creativity and one sees folk in evening classes minutely copying colour and details from photographs, something much better done by sending the negative to the processors. Such activity has given photography a bad name – justifiably so! On the other hand, the camera used properly can be of immense help to the painter. An enormous number of artists work from photographs – including those who wouldn't admit it! And many of them do so with great imagination and effectiveness.

A photograph should only be used as a 'jumping-off' place and the next stage is a series of little tonal sketches to improve the composition and resolve the values. To do this properly you must first have had the experience and knowledge gained from working on location.

One advantage of using photographs is that you can collect a lot of useful material in a short time. Sometimes there just isn't time to sketch all the material that you'd like to take home. My own camera is kept in the glove compartment of my car, and many's the pretty stream I've photographed from a bridge after

Zoom lens, and the way it can enlarge distant objects progressively.

The wide-angle lens and the way it can encompass a close object, which would normally be too near to be included in the frame.

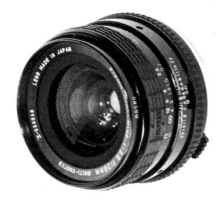

a hasty look in both directions!

It's much better to use a combination of both sketches and photographs, rather than just rely on the camera, you can then use the sketches for ideas and the photographs for details. The greatest danger in using photography is that you're tempted to include only the things that you can see in the print – and that very important factor of selection and rejection which is the major contribution by the artist may be forgotten.

I also think it's important that the photograph you do paint from should be your own, something that you yourself have observed and experienced at first hand – this will help to give your finished work more conviction.

As an artist you should be looking beyond sterile mimicry. Endeavour to put your own personality into your work whether or not you get help from the camera. I think that the camera can be a legitimate part of an artist's equipment as long as the results from that are used inventively and creatively. Let's face it many of the Impressionists such as, Degas, Toulouse-Lautrec and Sickert certainly did.

Having said all that, there are a lot of terrible photographers around, including painting students! They somehow forget all the common rules of composition they know so well when they get a camera in their hands. A viewfinder can be a creative thing in itself – the tiny area where you should be able to exercise your good taste and knowledge, but I'm afraid that out of every twenty pictures that are shown to me by students, nineteen of them are bland, boring flat-looking efforts and the odd one where the composition is well-balanced and exciting probably only happened by accident! Students look through my photographs and say, 'You must have a super camera to take these', whereas in actual fact the quality of the camera

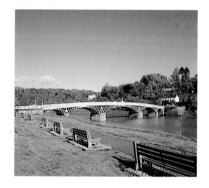

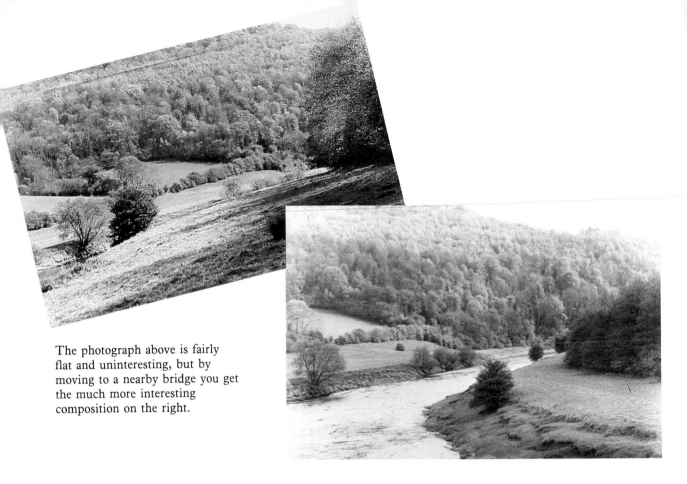

The photograph above is fairly flat and uninteresting, but by moving to a nearby bridge you get the much more interesting composition on the right.

The shot on the left shows a long distant view which is very impressive, but in the photograph the foreground field is boring. However, by moving behind a nearby rock and foliage you get a much more interesting sense of depth as shown below.

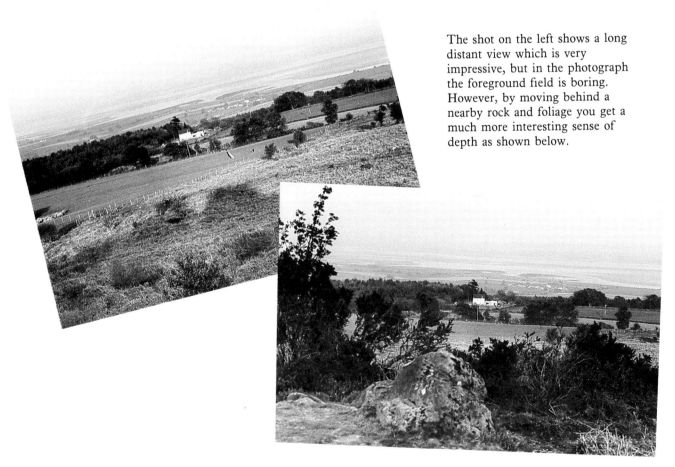

itself is, within reason, irrelevant.

It might be a good idea if I can pass on a few helpful tips on photography as one step in the process of forming your art.

First the camera itself. I graduated from the usual, simple plastic camera when I capsized my canoe and had to fish it out of the river – it was never quite the same again! Taking my courage and wallet in both hands I went and bought a 35mm SLR (Single Lens Reflex) camera. At first glance it was bristling with frightening nobs, but after I'd spent an hour playing with it I found it was almost 'idiot' proof. In my usual simplified way I take almost everything at 1/125th second, focus it and let the camera work the rest out for itself!

The advantage of an SLR is that in addition to the standard lens you can buy other lenses which can be changed over quickly. This may sound daunting, but the two extra ones I use have a definite and logical purpose, although most of the time I use the standard lens. The zoom lens means that you can magnify and photograph a distant subject such as a cottage rather like using a telescope. The wide-angled lens means that you can take a picture of a whole church across a street that would normally be too close to get into the whole frame. If all that sounds a bit technical it isn't – it's a lot less complex than a cooker!

Having got familiar with the workings of the camera the most important thing is the viewfinder and learning to compose a picture within it. Don't just point the camera at a subject and press the shutter – walk around and look at it from all sorts of different angles and arrangements before you even think of taking the picture. Forget about that breath-taking view from the hillside. If it looks boring in the viewfinder – don't take it!

The next thing is that, like your paint, you mustn't be mean with your film. You're bound to waste a few frames even when you do get competent, and you'll need plenty of information from different viewpoints on any particular scene so have a few spare films with you. Walking along the river bank you always seem to find the perfect composition and lighting just when you've finished your last shot – probably it's called 'Kodak's Law' or something!

I've shown here some good and bad examples of typical photographs – study them carefully then be as critical about your photographs as you are about your paintings.

do's and don'ts

A lot of students say, that although the agree with my basic principles, when they start painting all their good resolutions fly out of the window – what they need is a constant reminder. Indeed, some have listed a few of the main points and pinned them up permanently above their easels. So I've provided a ready-made list to photostat and stick up in front of you!

do's

Do a tonal sketch first – to establish your values properly.

Do give your audience something to interpret for themselves – they love it!

Do choose a simple subject – then simplify it even more!

Do remember if you're going to have a failure – let it be a glorious failure, and not a meek, miserable one!

Do think hard *before* you put the paint on the paper – *not* afterwards.

Do remember that, like golf, the fewer strokes you use the more professional it looks.

Do remember that your job as an artist is to capture the essence of a scene – a distillation of it – leaving out the superficial clutter.

Do set yourself a time limit, sometimes – it gets the adrenalin flowing.

Do remember that washes are bound to fade back when dry, and always compensate for this.

Do use contrasting techniques in a painting – wet-into-wet alongside dry brush – sharp against soft etc.

Do remember when painting on a wet surface to compensate by using a much richer mixture of paint on your brush.

Do remember that a complicated scene needs a simple sky – an elaborate sky needs a simple foreground.

Every stroke you put on that paper should mean something – if not it shouldn't be there!

*don't*s

Don't overwork your painting – stop as soon as your basic message becomes evident.

Don't make your foregrounds too fussy or muddy.

Don't put too much pressure on your brush especially the 'Hake' – think of it as a feather.

Don't put too much detail in your backgrounds – keep them as a simple flat wash.

Don't let that white paper intimidate you – it can't hit back!

Don't use tiny brushes – they're an absolute invitation to fiddle!

Don't be afraid of leaving uncluttered space – paintings need areas of silence as a foil to all the busy bits.

Don't use too much water – a swimming palette denotes a weak painting.

Don't be mean with your paint.

Don't make your heads too big when you're painting figures.

Don't make your skies too safe and weak – frighten yourself a bit!

Don't forget about counterchange.

AND YET AGAIN – DON'T FIDDLE!

demo 1 Greek island beach

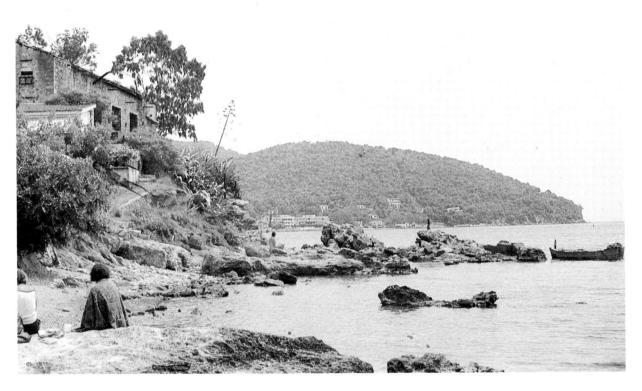

A beach scene on the Island of Poros.

In the next thirty or so pages I am going to talk you through eight paintings, not, as many books do, to show you all the stages wash by wash which I personally find a bit boring (I always feel the stage before the last looks the best!) No, I feel it is more important to try and describe the thought processes that go through one's mind when faced with a subject, even before getting the paints out.

I feel it's your job as an artist to make a distillation of the scene in front of you without any superfluous clutter. Perhaps to dramatise certain parts and subdue others or to give a more safisfying curve to a beach – not hesitating to move rocks or trees around if, in your taste, it improves the composition. I'm going to show you a tonal sketch of each scene in which many of the main problems can be sorted out before you start worrying about colour mixes and brush techniques.

This first painting is a beach scene on the Greek island of Poros (where I am actually writing these words). I bring about 20 students here every spring for a two week painting holiday.

Let's look at the scene critically and assess it. Basically it is in two planes. The first is the far distant hillside which must be kept simple and subdued, with absolutely no detail (even if you can see hotels there!). In the second, nearer, plane are the villa, rocks and beach which must be stronger, richer and more contrasting to bring them forward.

The villa itself is actually derelict, but I'm going to make it more dramatic by building up the trees round it to counterchange with it. I felt the eye could be taken gently down to the boat with some flowing steps, and I've cleared a more definite path, too. I've given a cleaner and more defined curve to the waters edge and beach which I feel improves the composition. Also I've emphasised the rocks in the centre of the picture by building up some foliage behind them. Finally, I've added a couple of appropriate figures. The rocks themselves have been somewhat formalised and I have hinted at a reflection of them in the water.

Do not make the sea a regulation blue all over, as I have seen so many beginners do. I have added a touch of Raw Sienna near the shore in the foreground as the sand below would influence the colour.

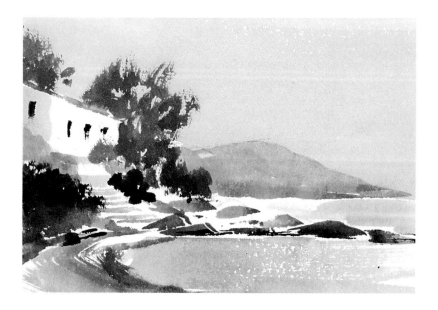

The preliminary tonal sketch.

demo 1 Greek island beach

If you compare the painting on the right with a photograph of the scene on the previous page you will see I have taken many liberties with what is actually there. I've ignored the hotels in the distance, removed some of the foreground rocks and generally cleaned the place up and smoothed the water so that I could legitimately put some reflections in.

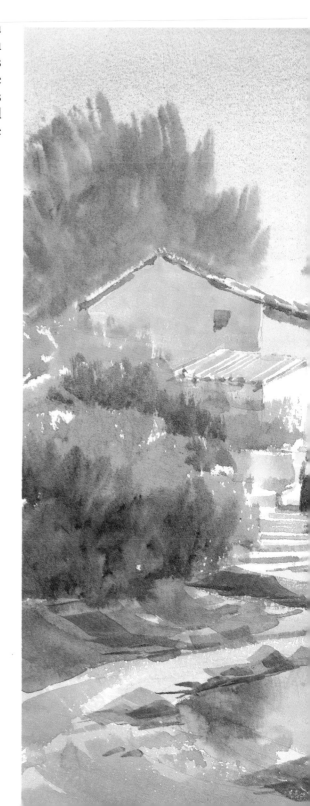

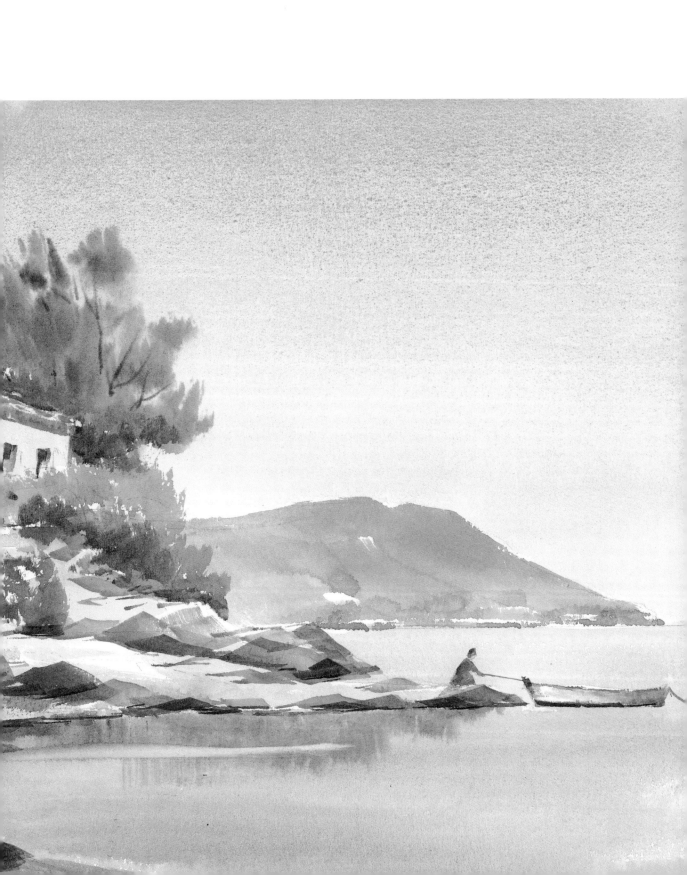

demo 2 autumn woodland

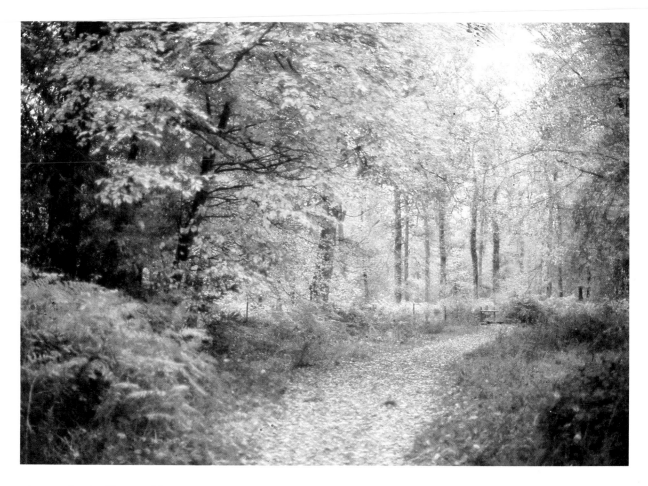

A scene in the Forest of Dean, near my home.

This is the sort of scene that seems to strike terror into so many students. 'Where do you start with a subject like that, there's nothing to get hold of!' they say. My own way of tackling it is to work gradually and systematically from the background to the foreground.

As the title says, it's an autumn scene and as such it provides a temptation to put too much crude colour together. There are plenty of opportunities to use the Light Red, but it must be tempered with a few subtle mauves and pinks in the distance.

Looking at the scene I felt it needed a more definite path to take the eye in and guide it to the distant sunlit trees, making almost a rich tunnel to look at the patch of light beyond.

First I washed in the whole sky down to the horizon line, then while this was still damp I painted in a mixture of Ultramarine and Light Red to indicate the distant trees in the

gap. I used the rigger to show the trunks rather wet-into-wet.

Then I started to build up the colour strongly on each side. This is the point the painting often starts to become muddy so work lightly and decisively, gradually using stronger and stronger paint. As the paper dried, I finished off the trees with light touches of dry brush at the edges of the gap. This is where the rigger comes into its own, but one must not overdo it, but save it for the light patches where it shows up better. A few flicks with the finger nail into the still damp paint also helps.

The same treatment is used for the ground undergrowth, this time I put in a wash corresponding to the lights and only partly covered them with the darker colour later. Here again I used my finger nail, rigger and even my knuckle to add texture.

The path was indicated with a weak wash of Light Red and when it was dry I put in the shadow very quickly and decisively with a mixture of Light Red and Ultramarine.

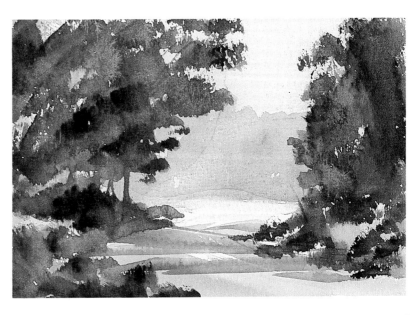

The preliminary tonal sketch.

demo 2 autumn woodland

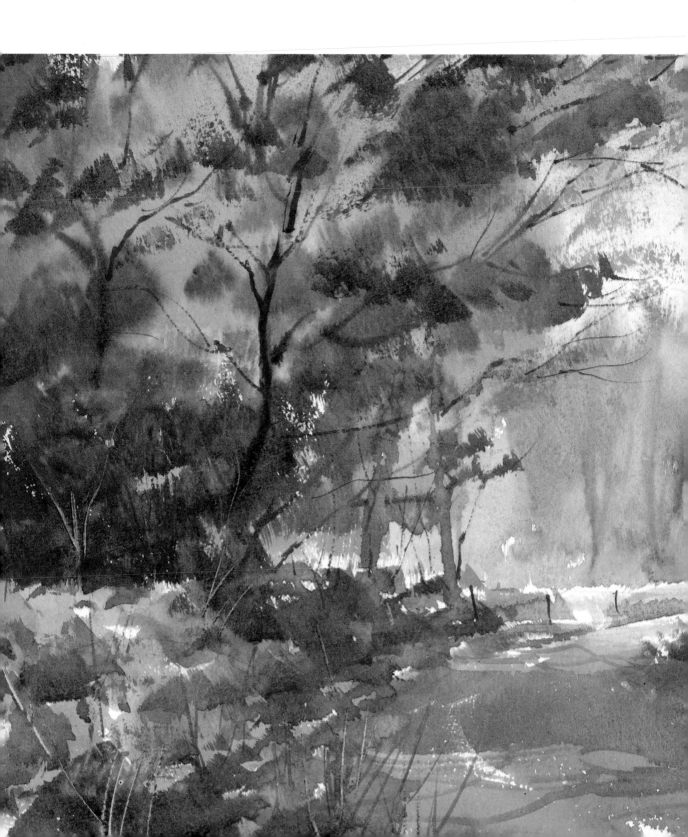

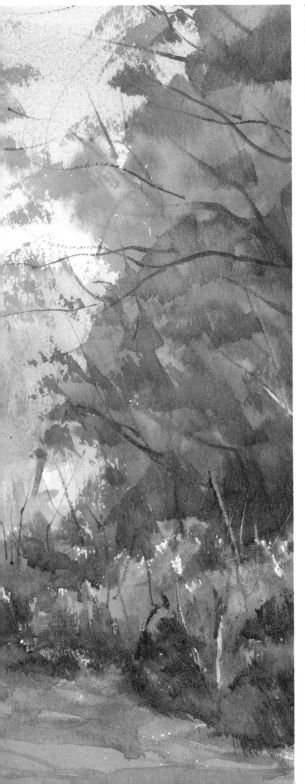

Comparing the photograph on page 84 with this painting you'll see my main aim was to take the eye down a definite path to the patch of light at the end. To dramatise it I gave the surrounding trees a more definite textured profile – in other words to try and build in more depth.

demo 3 Greek windmill

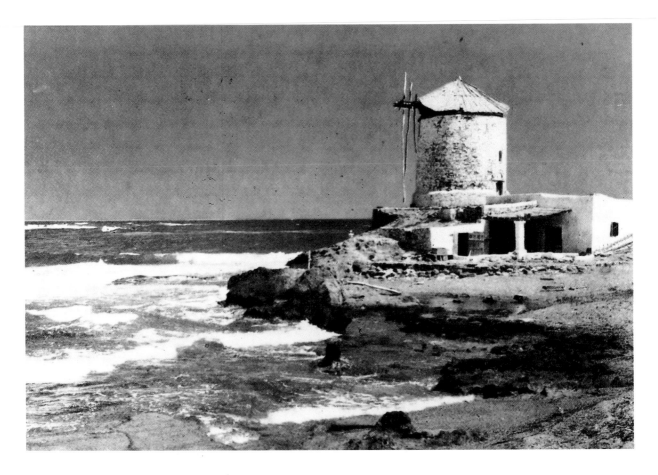

A typical Greek island windmill, sadly neglected but a wonderful subject to paint.

This one's a real 'natural'. Compositionally it's perfect. The whole windmill is silhouetted nicely off centre against a rich blue sky and provides a good vertical element combined with the horizontal skyline – even the waves seem to radiate and point to the main object of interest.

I like the counterchanged lights and darks at the base of the mill, and also the counterchanging of the dark rock in the middle against the white foam of the sea.

This is one of the very few occasions where I would use masking fluid to cover the windmill before I put the sky in. In case you haven't used it before, it's a rubbery solution which you paint on the part you want to leave white. It dries almost immediately to a waterproof film so that you can paint over it with confidence. Once the watercolour washes are completely dry you can rub the masking fluid off with your finger.

Having let the fluid dry, I first put a thin watery wash of Raw

Sienna all over the sky. I immediately put on a strong wash of Ultramarine with a touch of Light Red in it across the top of the sky, and graduated it by taking the pressure off my brush as I moved it backwards and forwards. Even rich blue skies are weaker and creamier at the horizon than they are at the top.

When that was dry I put in the distant sea with a very sharp horizon, but only as far as the distant waves. This left a natural break and from there to the foreground I changed the colour of the sea by adding Lemon Yellow and weakening it, using the direction of the stroke to give movement to the water and leaving lots of untouched white paper for the waves. Like all moving water I try to indicate it as quickly and lightly as I can.

Next came the beach, and I wanted to introduce as much texture and varied colour into it as I could, although it's basically Burnt Umber with a touch of Raw Sienna.

Having done all this, I rubbed off the masking fluid carefully. Don't leave it on for days as I have known it remove the surface of the paper as well – not my favourite stuff!

Left with a nice white silhouette, I used my one inch flat brush to put in all the varied tones using the absolute minimum of strokes, and in some cases lifting the brush at an angle to get a shorter mark. I strongly resist the temptation to use a smaller brush because I feel the large one forces you to simplify. Even the texture on the roof was done by radiating it.

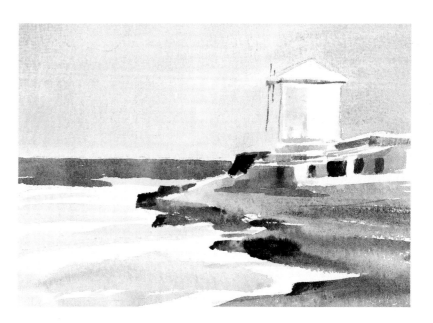

The preliminary tonal sketch.

This is a much 'tighter' painting than most of those in the book but it just came out that way. To let you into a little secret, the wash on the sea near the horizon became a little 'muddy' and I cheated shamelessly by rubbing a little pastel over it. Certainly not to be encouraged, but a useful tip in an emergency and one could call it mixed media!

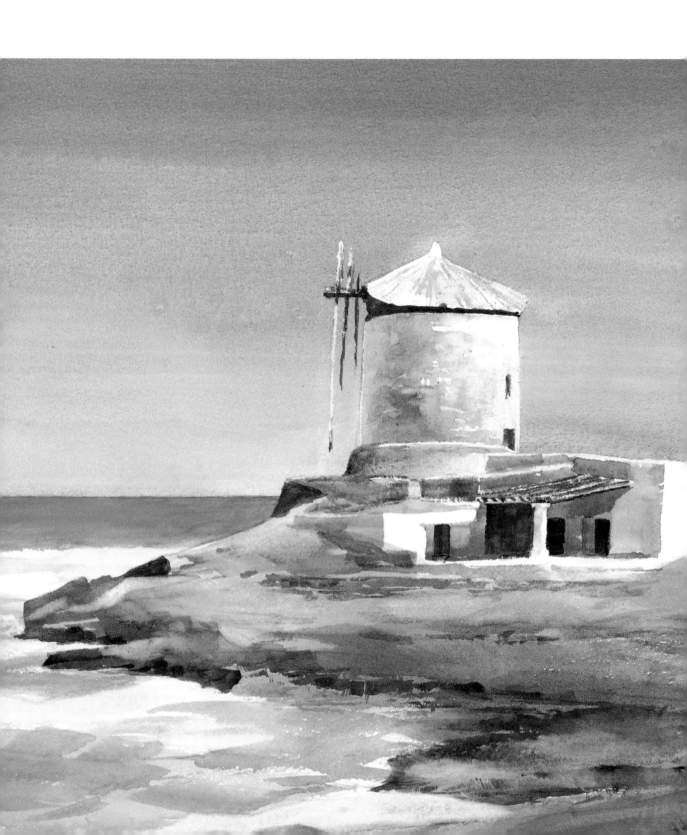

demo 4 Welsh rapids

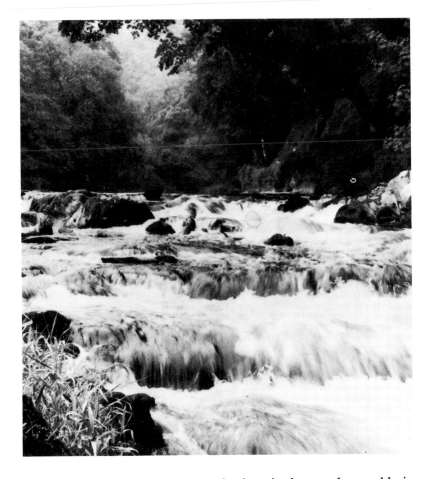

The fast moving Cenarth Falls in Dyfed, Wales. A challenging but exciting subject.

This was a very exciting scene, both to look at and to tackle in watercolour. When you first get there and see and hear the rushing water it seems an almost impossible task to portray it. What you must do first is to stand quietly and study the water closely for some minutes. What at first seems a constantly changing succession of lights and tones can be resolved into a pattern which occurs over and over again. It will be easier to discover if you screw your eyes up until they're almost closed.

But let's start with the sky first – a very simple one here, remembering that a complicated and busy foreground needs a peaceful backdrop otherwise the two will fight each other.

Once the sky was in I wanted to show three separate planes of woodland, one behind the other. I put the furthest one in first, on to a still damp sky. Then I added the left hand bank of trees almost immediately, but in thicker paint. Finally, I made up a

large quantity of rich dark green while the other washes were drying and then put it on quickly and strongly in one coat using the corner of my hake to produce a nice 'frothy' edge which throws it forward from the far trees. This is probably the most hazardous part of the painting as regards 'mud'. The dark colour must be put in directly and then left strictly alone – there is a terrible temptation to keep painting it in a damp state, which is fatal.

Next the river banks themselves, which are lightly indicated by brushing the hake at an angle.

The river itself should be put in very lightly and rapidly leaving lots of untouched paper for the white water. This is where you should do one or two trial shots on a piece of scrap paper. Once rehearsed you will do it with more confidence.

When this is dry the foreground is put in quickly and decisively. Once again remember not to overwork it. It is so easy to ruin the freshness of the whole painting with 'mud' so try out this corner, too, on scrap paper – rather like a golfer on the putting green testing his strength before actually addressing the ball itself.

The white branches in the trees on the right were flicked in with my finger nail while the paint was still damp. If you try it whilst the paint is too wet they will fill in to produce dark lines. Please do not get carried away with it – use it with discretion.

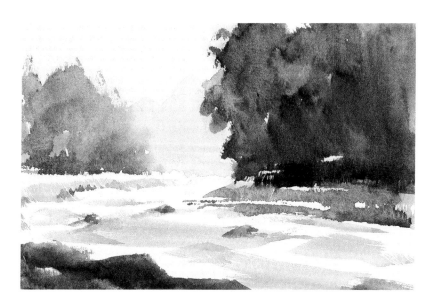

The preliminary tonal sketch.

demo 4 Welsh rapids

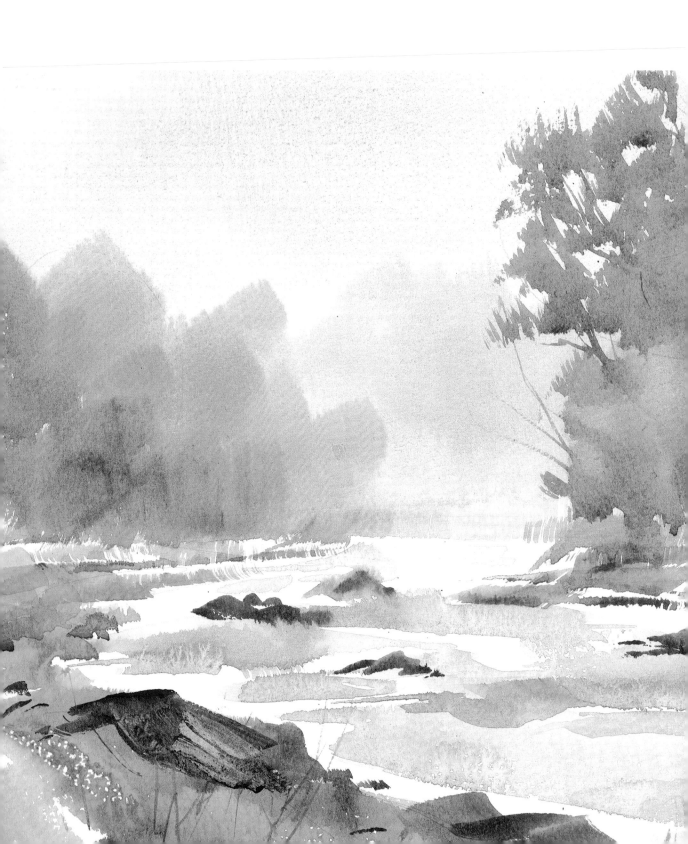

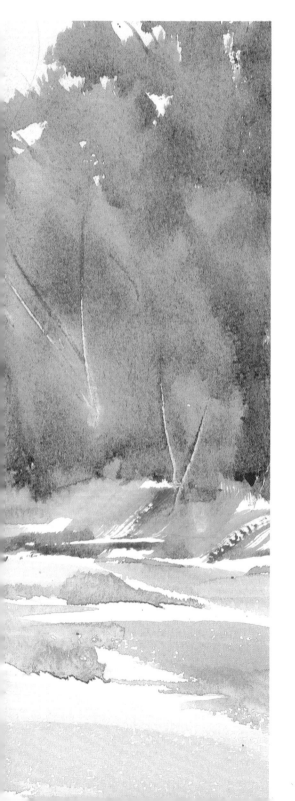

In this painting I've very much simplified the scene on page 92, having made no attempt to reproduce each individual eddy and fall. I've merely tried to capture the spirit and movement of the river. I have given it a more winding path to follow and, of course, tried to give the scene more depth.

demo 5 woodland stream

This is a really wild one! A jungle of matted undergrowh and tangled branches, it presented a real challenge to simplify and paint in order to give an impression of the scene in a light, fresh way.

One thing I liked about it was the strong light silhouetting the background trees on the left. The ivy-covered trees in the centre were moved slightly to the right and I decided to strengthen the tonal mass in the left foreground to give the scene more depth.

With a scene like this you cannot possibly hope to reproduce all the branches and grass. You must instead try to portray it in counterchanged tonal masses and various mixtures of green. It's easy to produce a very boring range of greens, and you should try to deliberately contrast a 'bluey' one against a 'yellowy' one, a dark against a light one. Notice how I have tried to do this, particularly on the right side of the painting.

One of my favourite subjects, a combination of water and trees.

The main aim should be to keep it fresh and transparent – paint with the lightest of touches and avoid 'mud' like the plague!

I feel this sort of picture is an ideal way to contrast the forced simplification of the hake with the free calligraphy of the rigger. The sequence is the same as usual, starting with a simple sky wash leaving plenty of light at the bottom left.

Whilst the sky is still wet, start putting in the distant woods on the right with blue-green, then gradually build up the foliage, waiting until the sky is absolutely dry before introducing the rigger work and the two main ivy-covered trees. The trunks I did with light sideways strokes of the hake. Again you will see a few flicks of my fingernail in the damp paint on the far right – much more effective against the dark tones.

The stream was then washed in quickly with the same colour as the sky, and the other colours of the reflections dropped in immediately in thicker paint to compensate for the already damp wash on the paper.

Finally, moving forward again, I painted in the foreground tree and the bank on the left quickly and lightly to avoid over-working them. Notice the little wriggles in the river to reflect the foreground grasses.

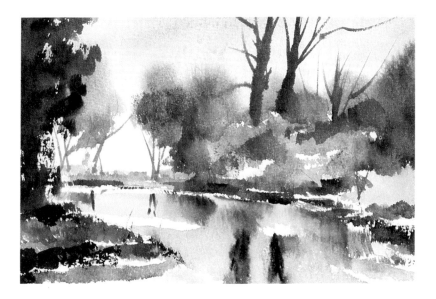

The preliminary tonal sketch.

demo 5 woodland stream

Compared with the actual scene on page 96 you will see that the painting on the right has been considerably simplified. I have tried to use washes of transparent paint to represent the network of branches again, while trying to retain the essential character of the scene before me. I've also tried to clarify the various depths of the picture, for example the foreground tree on the left is separated tonally from the trees behind it.

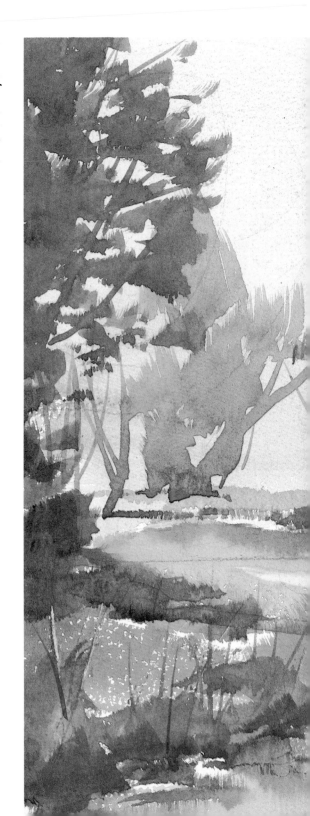

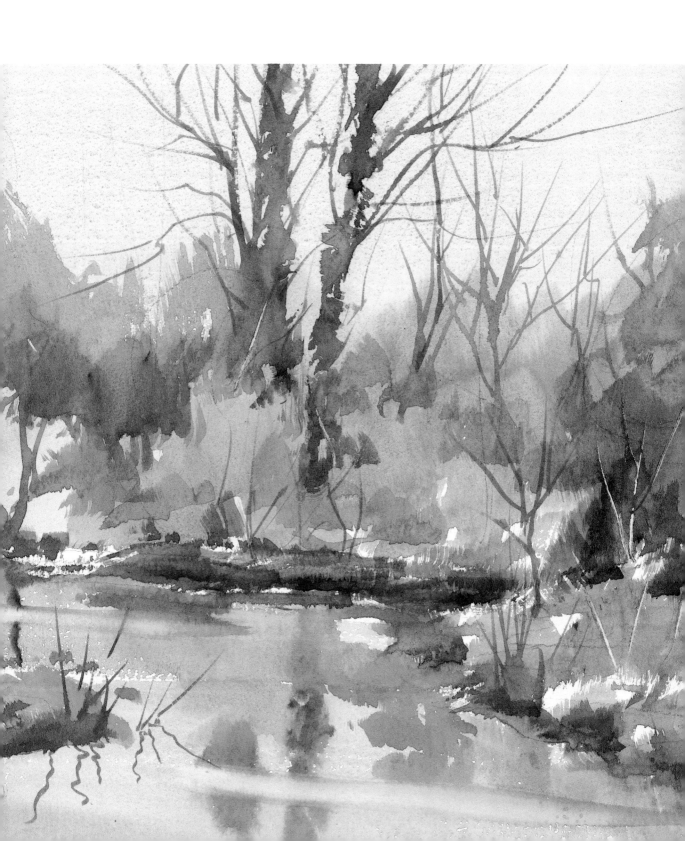

demo 6 winter scene

I loved this scene. It gave me a chance to put a lot of depth into the picture and also provided an opportunity to slow a variety of different textures and techniques which made it a good demonstration painting.

First I decided to separate the two foreground groups of trees to give a clear view of the distant wood across a field that was partly covered with snow.

After putting in the sky I painted in the distant wood right across the painting, ignoring what was to come in front. Students often leave white gaps for nearer trees which then have to be added in like a patchwork quilt. Unless the foreground tree is much lighter than the background, forget it at this stage.

The next move was to put in the left hand group of trees with light downward strokes of the hake, well charged with paint, using the corner of the brush to indicate the feathery bits on top. While the paint was still damp I pushed the nail of my

The cold, misty atmosphere of this river scene make it an ideal watercolour subject.

100

little finger up once or twice to show the lighter branches. Then using the rigger I indicated the main branches against the sky which was by this time dry. Don't be too impatient here. If they're put into a wet sky they look blurred and unnatural.

Next the bank was put in using almost pure Raw Sienna dragging the hake lightly as a feather at an angle to indicate the slope of the bank and leaving plenty of white paper showing for the snow.

Then comes the right hand fir trees. Try practising these first on a separate piece of scrap paper. They are a combination of hake and rigger. The main trunks are touched in lightly with sideways strokes of the hake. The foliage is shown by flicking in strong paint using mainly the corner of the brush. Finally, the branches are added with light strokes of the rigger. The more practice you have in this the more decisive and confident you will get with your trees.

I tipped the posts in with my one-inch flat and was ready for the river. This should be a mirror image of the sky colour and while still wet I put in downward strokes of the tree colour using very strong paint to compensate for the wetness already on the paper. I then did a quick sideways stroke with my dry hake to wipe off a streak, indicated the reflections of the posts and the picture was finished.

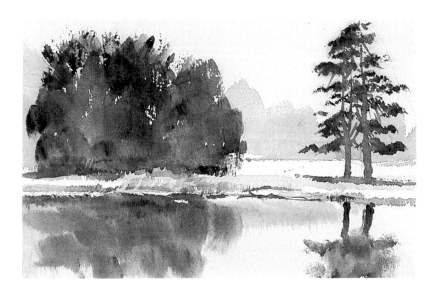

The preliminary tonal sketch.

demo 6 winter scene

If you compare the scene on page 100 with the painting you'll see that my main aim has been to drastically simplify it, give it more depth whilst at the same time try to retain the cold misty atmosphere. The trees themselves have been formalised to some extent. Note that whilst the right hand pair of trees in the photograph has had its top chopped off, I've retained it within the picture.

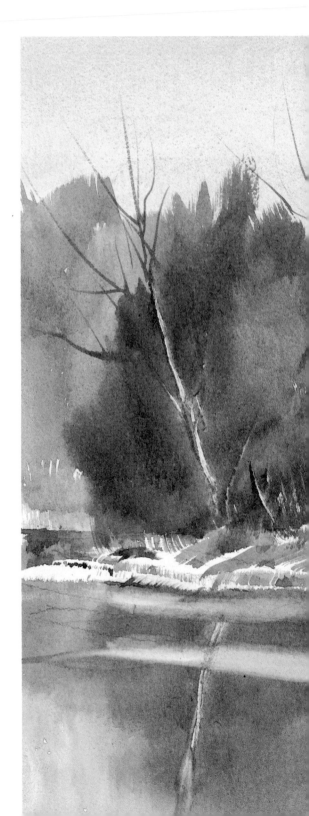

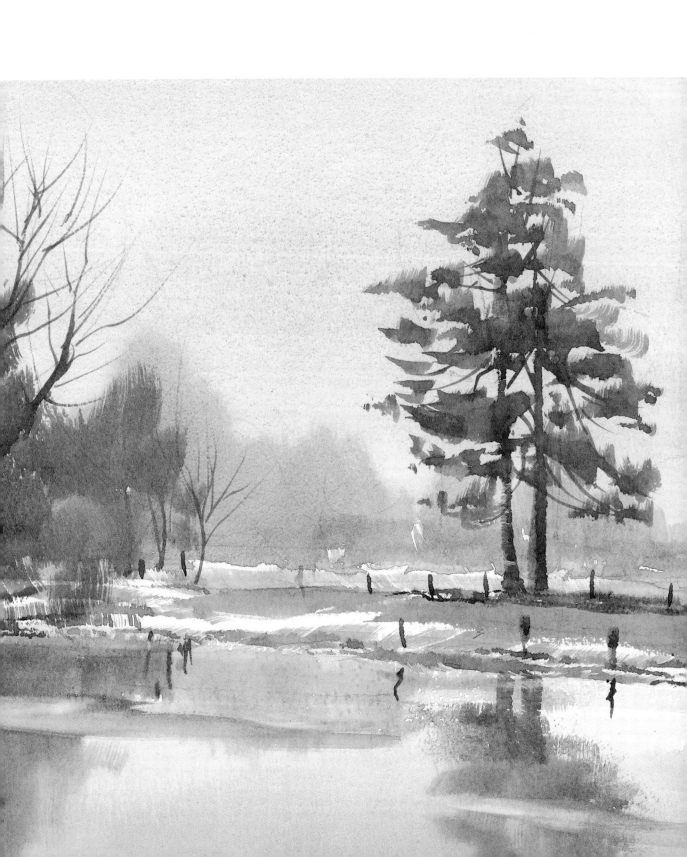

demo 7 lakeland view

I had been asked to do two demonstrations on two separate evenings in the Lake District. In between I drove my car around all day, painted three watercolours, took dozens of photographs, and thoroughly enjoyed myself.

I drove over the brow of a hill and saw this scene below me. The lake on the left provided the one streak of light in an otherwise fairly sombre panorama. What attracted me however, was the plane after plane of depth in it.

The weather was sunny one minute and threatening the next, so I was determined to produce an exciting sky with a hint of rain on the right hand hills.

I first put in a very weak watery wash of Raw Sienna on the sky area and then immediately dropped in a patch of blue and quickly mixed up a strong mixture of Paynes Grey and Alizarin Crimson. This is one of my favourite mixes for clouds. One has to be careful to get the mix with just the right balance – too much grey and the colour is too 'slatey'; too much Alizarin and

It's no good asking me exactly where this is because it's a scene I discovered when I was completely lost!

104

it looks 'sugary'. Remember, too, that it will dry lighter than it looks when wet so you must apply it with fearless abandon to the damp surface – really frighten yourself. Then tip it up at about 45 degrees and watch it all happen – it's very exciting and the result depends on getting the water content right.

From then on I worked the picture from the back to the front. Notice the far hillside – at each end I deliberately pushed the wash into the still wet sky to blend into it, whereas in the centre I avoided touching the sky, leaving it as a hard edge.

The dark wood behind the lake was put in with a rich mixture of Paynes Grey and Lemon Yellow whilst the background wash was still wet.

The lake itself was left completely untouched letting the white paper speak for itself. Then with one light stroke of the hake I put in the middle distant plain indicating the trees with the corner of the hake, and the hedge with a touch of the edge of the hake.

Finally the foreground went in on top – the grass with a quick light sweep of the hake, leaving a few bits of untouched paper on the left which I feel gives it a certain touch of vitality. The foreground trees went in with dry brush leaving a few spaces through them to indicate branches with the rigger.

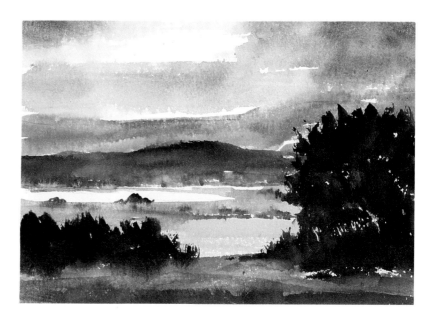

The preliminary tonal sketch.

demo 7 lakeland view

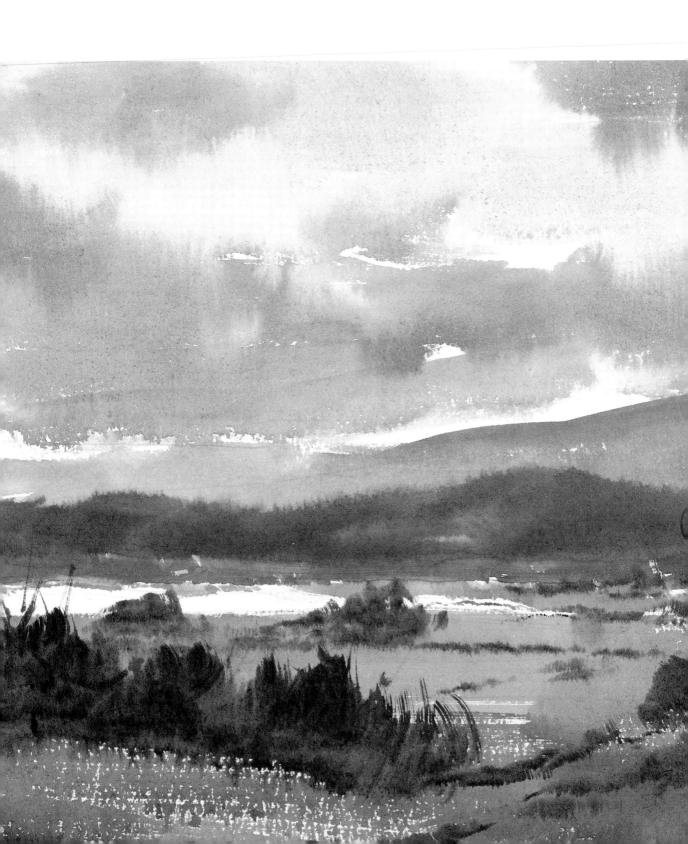

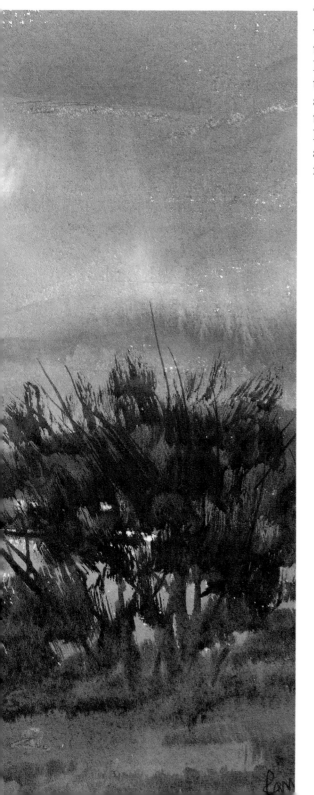

The main difference in this painting compared with the photograph of the scene on page 104 is that I've made much more of a sky picture of it, lowering the horizon which in the process reduced the foreground. I tried to get a lot more drama and atmosphere into the scene. Note too that I've tried to provide a clearer path into the picture by leaving a gap between the foreground trees. I've also lowered the right hand tree so that the top is not touching the edge of the distant hill.

demo 8 snow on the Wye

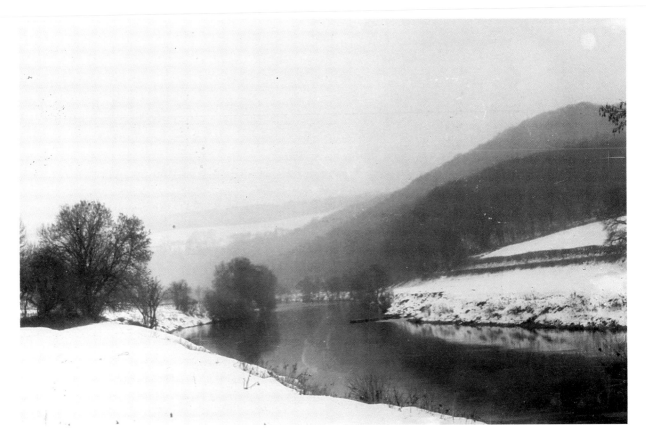

The River Wye at Bigsweir, the view from my bankside studio.

This is a scene on the banks of the River Wye about half a mile, as the crow flies, from my home. I look down on this river from 800 feet above it. I regard it as almost my own back yard and paint on the bank throughout the seasons. I even have a studio on its banks which was originally a toll house for the bridge. Much of the time it has mist in the valley and makes an absolutely ideal watercolour subject.

There is plenty of opportunity to use the wet-into-wet technique in this scene, but again I must stress not all the way through or it will look like candy floss. You must introduce strong sharp darks as well to give the eye something to focus on, such as the tree on the left. A few delicate touches, like the protruding grass in the foreground help, too. I restricted myself to four colours, Raw Sienna, Burnt Umber, Paynes Grey and Ultramarine.

Look at the scene itself. There is not a lot that needs changing. It's almost a natural, with the eye entering the

picture on the right and being led gently to the river. The dark hillside on the right balances up the even darker tree on the left.

The most difficult part is handling the wet-into-wet and the secret here is not to use too much water once the first wash has been applied. As always, I worked from the back to the front of a painting.

I put in my sky with very weak Raw Sienna then dropped in some Paynes Grey across the top and allowed it to graduate downwards by gravity. Then came the far distant hillside where I used much thicker paint on the still wet sky. The two mid distant trees were then touched in using almost neat paint.

The river was then tackled. I quickly dropped in the sky colour all over and quite wet. I immediately put in the reflections of the hillside, and afterwards the trees in quite thick paint. Having dried my hake, I wiped out two streaks while the paint was still wet.

The hillside and sky on the left were by this time dry enough to put in the near tree – painted lightly with almost neat paint – carefully leaving plenty of 'sky holes'. That done the river was dry enough to indicate the rushes in dryish Burnt Umber.

I then flicked the shadow on the snow very quickly with the hake and very thin paint. When this was dry I added a few whisps of grass. It took in all about 20 minutes.

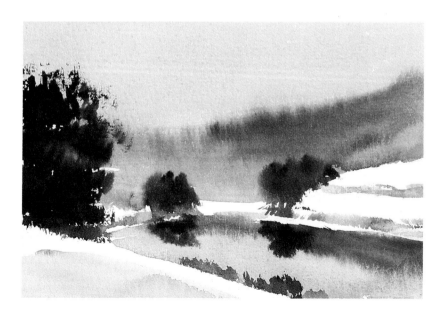

The preliminary tonal sketch.

In contrast to many of the previous demos a comparison with the actual scene on page 108 will show that very little had to be done to simplify it – perhaps the snow had done it for me! Mainly I've increased the size of the foreground tree on the left to give it more importance and emphasise the depth of the scene. I also felt that the foreground snow needed a little more interesting texture.

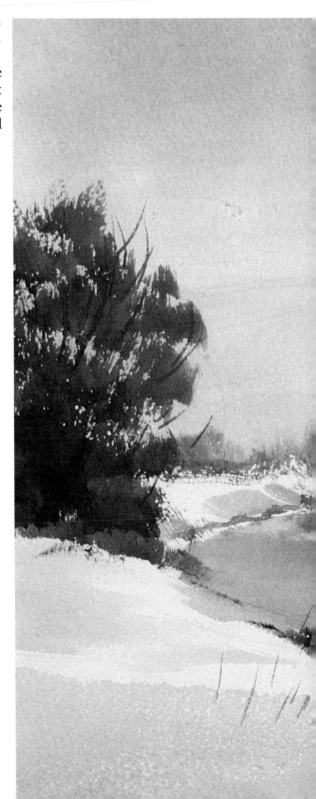

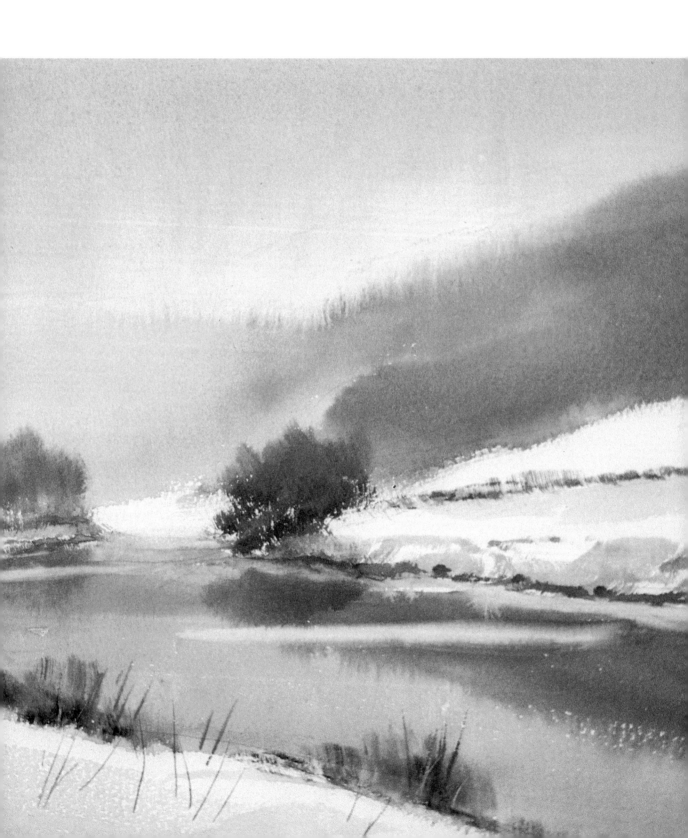

my own collection

Now I'm going to take you around my home and show you my own collection of other watercolour artists' work. Pictures which, each in their own way, have over the last few years stopped me in my tracks and filled me with a desire to have them on my walls – paying hard earned money for them – sometimes more than I could sensibly afford! These paintings have, however, not only given me inspiration but have served as a constant reminder of my own aims, gently helped to keep me on the chosen path as it were.

It's no coincidence that they all display the same approach to simplification and directness that I'm trying to achieve in my own teaching and painting. They are studied long and hard by the hundreds of students who visit Wyeholme; each provides invaluable help and guidance. I make no secret of the fact that I'm almost completely self-taught. Much of my knowledge has been gained from my vast library of books on watercolour which I've built up over the years from every country I visit.

The English painter Edward Seago has undoubtedly been my biggest influence. I have scoured the second hand bookshops searching for his books, all of which have been out of print for twenty-five years or so! I eventually decided that someone should do something to rectify this situation so I have produced my own book on his works which has just been published by David and Charles.

I have, however, also tried to train myself to carefully analyse the work of experienced artists whose work I sincerely admire. In these final pages I'm going to talk you through some of my favourites, which will help to emphasise some of the ideas on watercolour I've tried to convey in this book.

Thorpeness Mill Leslie L H Moore RI

I bought this on a visit to Furneaux Gallery in Wimbledon one day, captivated by its freshness and textures. Look how all the detail is concentrated on the mill itself, and the further away from the main point of interest the looser it gets. The foreground itself is very understated and fresh, with little to compete for attention, avoiding one of the major faults of most amateurs – too much fuss in the foreground. The sky is a delight, note the counterchange of the various depths of foliage with the darkest dark placed behind the white steps, also the way the eye is led into the left of the picture by the track. He has also added a few strokes of body white to pick out the cross-members of the gate etc but this is used with great discretion.

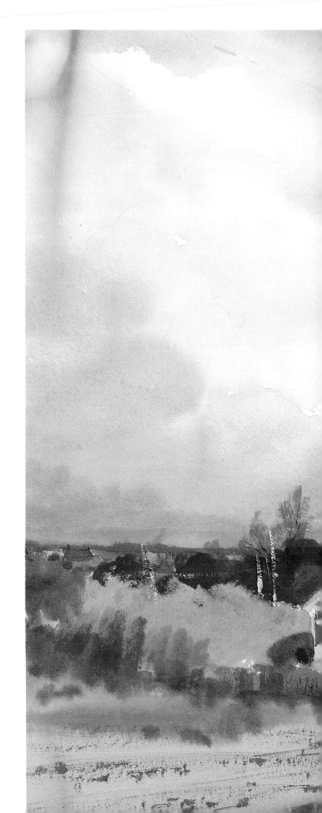

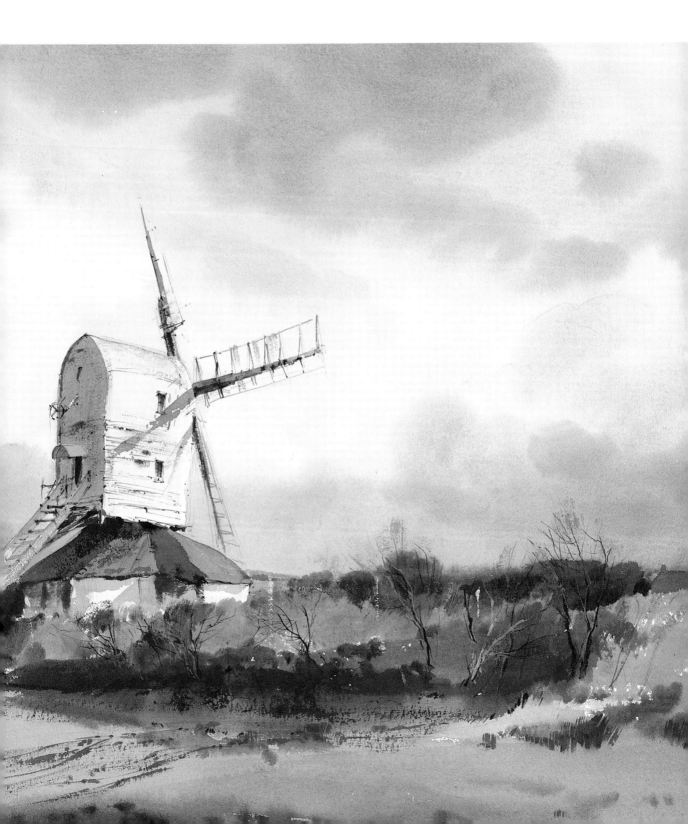

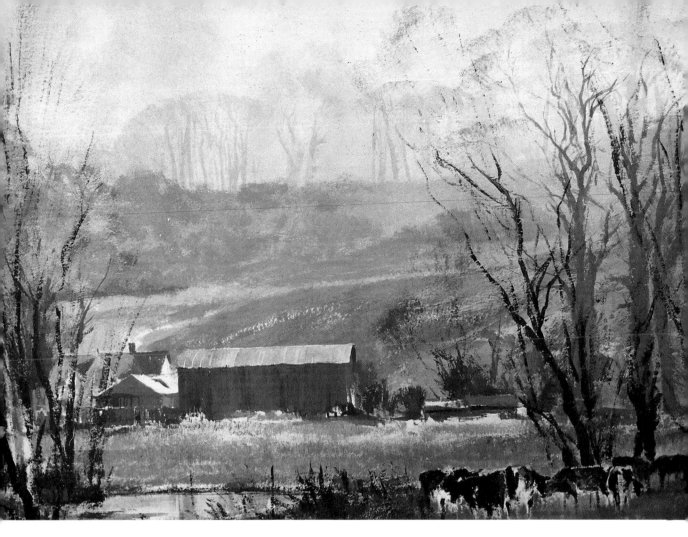

Upper Unsted Farm, Godalming Roy Perry RI

Like other artists shown in this chapter, such as Edward
Wesson and Trevor Chamberlain, Roy Perry only became a
full-time artist later in life. He was a winner of the RI Gold
Medal for the best watercolour of the year by a non-member,
before being elected to the RI in 1978. He works both in
watercolour and gouache and although this example is in
gouache I had to include it to show the handling of the aerial
perspective. From the beautifully rendered cows in the
foreground – themselves worth careful study – the painting
recedes plane by plane back to the wintry trees on the skyline.
Notice, too, how he counterchanges the farm roof against the
light background and the barn roof against a dark one. These
things often occur in nature, but if they don't you have to
arrange them yourself deliberately! Again look how the second
row of winter trees on the right is lighter than the foreground
trees.

116

Still Morning, Southwold Trevor Chamberlain RSMA, ROI

I've long admired Trevor Chamberlain's oils, so much so that
when asked to write a book about oil-painting I contacted him
out of the blue and asked him if I could illustrate the book
entirely with his work. He agreed and *Oil-painting Pure and
Simple* was the resulting book.

However, I was surprised and delighted to see one of his water-
colours in the RI a year or two ago and bought it immediately. I
now have three, all of which are shown here. *Still Morning,
Southwold* must have been a daunting picture to start,
particularly the complex detail on the left, but Trevor has
resolved it very successfully by simplifying the tones into three
separate depths. Note that the area of greatest tonal contrast is
at the stern of the right hand boat, making it the focal point of
the picture. Notice, too, the simple treatment of the water and
the handling of the reflections.

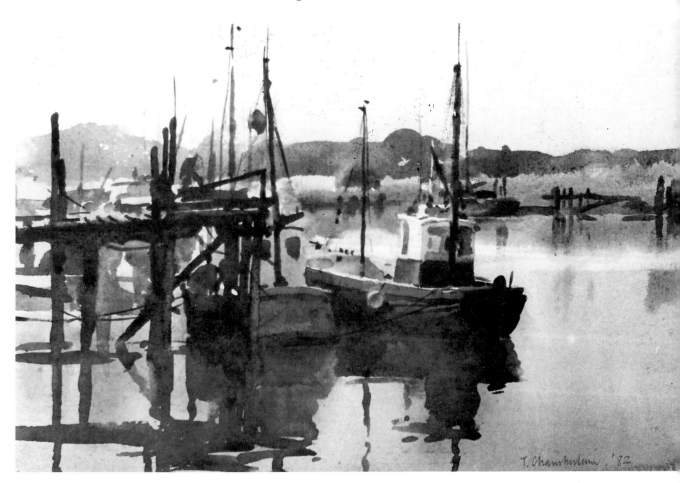

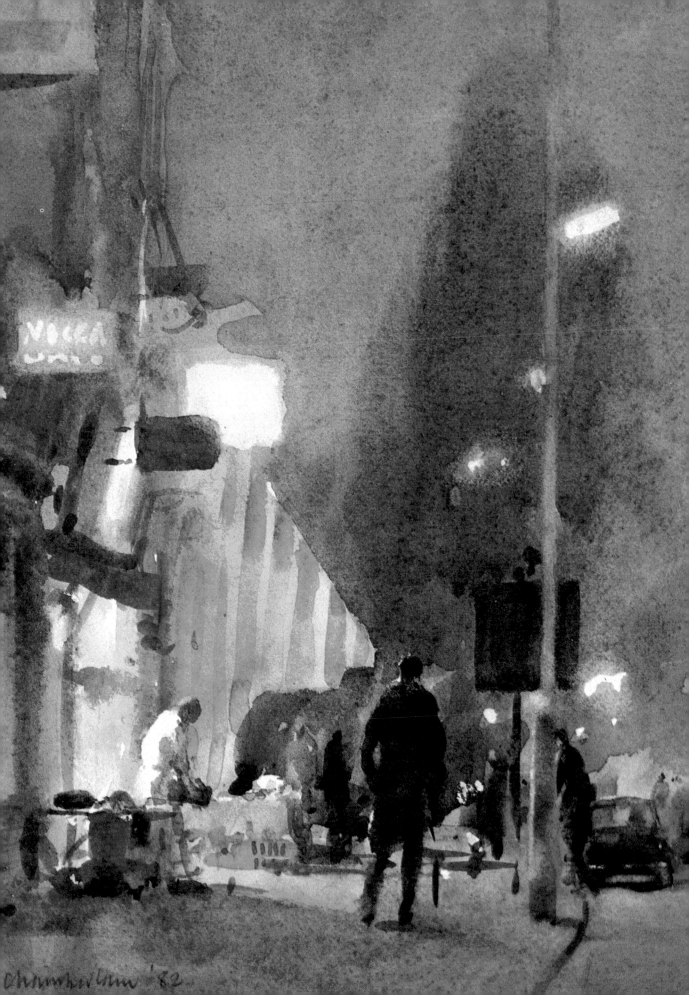

Shop-lit Pavement, Tottenham
Trevor Chamberlain RSMA, ROI

I asked Trevor how he came to paint this picture and he said he'd done it sitting in his car one night waiting for his son to come out of a disco! It's a beautiful transparent watercolour – with so many darks it could so easily have become 'muddied'. He has used counterchange very successfully throughout the picture – look at the way the white-clothed shop keeper is picked out against the awning, and the dark sign against the lit one. Even the distant figures and the 'mini' on the right are beautifully indicated.

Riverside at Hammersmith Trevor Chamberlain RSMA, ROI

I chanced to see this picture in black and white in the *Artists* magazine one day and drove about a hundred miles to a Devon Gallery to buy it. It has obviously been painted on tinted paper – something I haven't yet tried, though I've bought several sheets of such paper over the years in readiness! (Haven't we all?) I couldn't resist its masterly simplicity with lots of out of focus wet-into-wet, but good, sharp accents to hold the painting together. The three figures, too, have been placed strategically. Look at the way the dark one on the left is counterchanged against the light background.

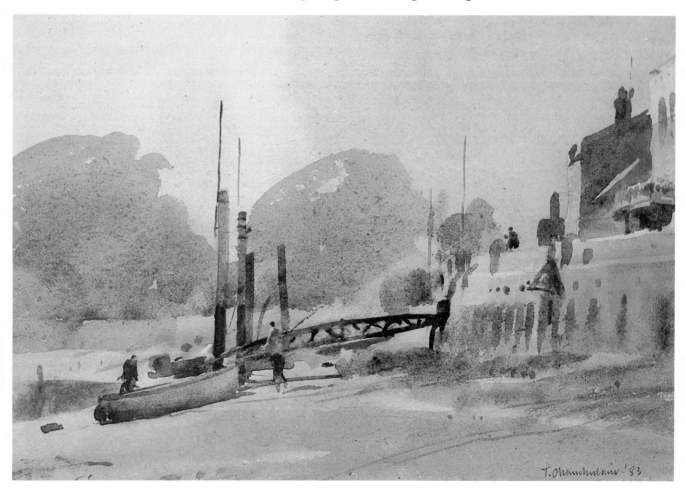

Kirkcubright Wood Mill Jon Peaty

I saw this painting in a converted cow stall behind a pub on the Yorkshire moors, and fell in love with it immediately, but felt that the price was a bit too much for me at the time and left. After a sleepless night I drove back sixty miles the next day to buy it! Years later I met the artist who had joined one of my workshops in Durham. The picture has all the qualities I admire, especially the sweeping, simplified foreground which I'm constantly showing to my students. The wet-into-wet tree on the right contrasts with the sharp crispness of the adjacent buildings. The eye sweeps over the foreground and is carried round to the edge of the water to finish on the tiny post in the distance. The two figures are also well placed with their heads counterchanged against the light patch on the buildings. The dark cloud on the left helps to balance the masses on the right. All in all, a thoroughly satisfying picture.

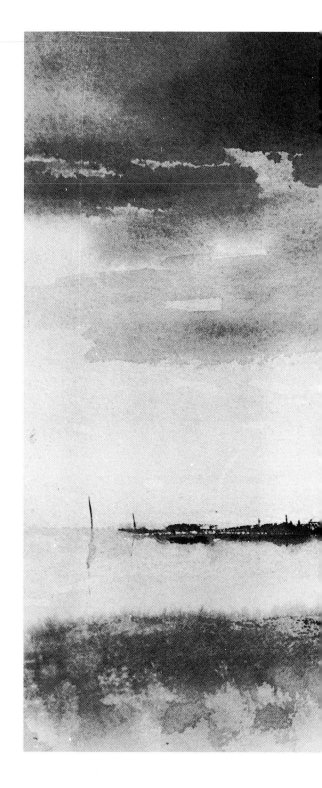

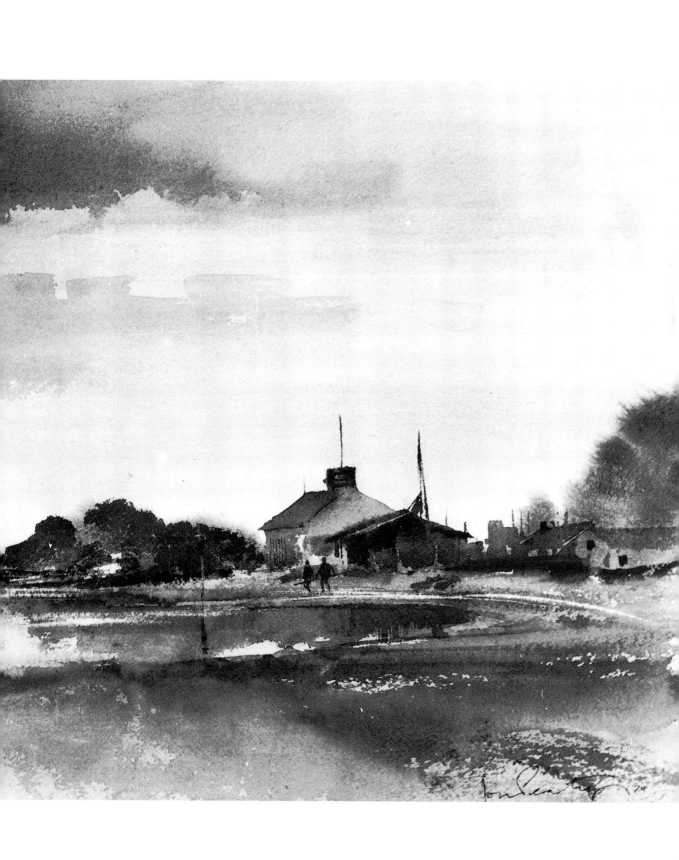

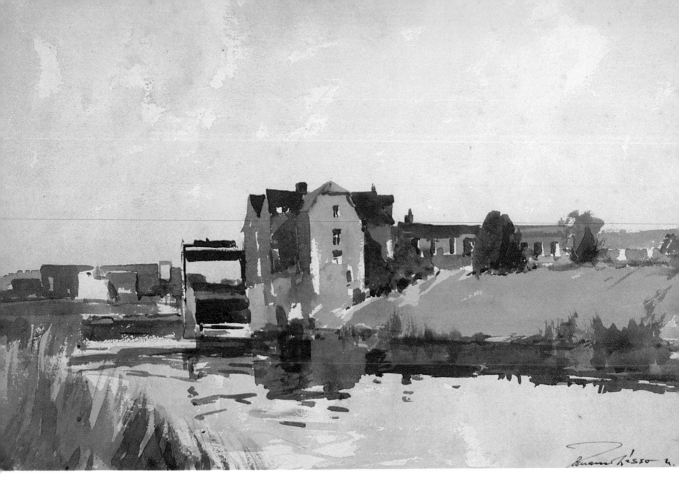

The Mill, Tewkesbury Edward Wesson RI

Ted Wesson was a real character, with a gruff humour, a really well respected and loved artist and teacher – his courses were always booked up months ahead and his Art Society demonstrations crowded out. His work and teaching have been an enormous influence on thousands of students. I had a week's course with him a few years ago which I remember fondly.

One of the ways he kept his work fresh, spontaneous and uncluttered was to use his famous 'polishers mop', in reality a crude looking brush made for French polishing. Its floppy hair was held together with wire, but it worked for him and his multitude of followers – having the same deterrent effect on fiddling as my 'Hake'.

This picture, one of four I possess, shows all his freshness and simplicity. His paintings were done quickly with deceptive directness and lightness of pressure. If I may quote from his biography, 'Watercolour doesn't bear being pushed about and worked on without losing its main quality. We need to simplify the subject in front of us so there will not be the need for any overworking or fiddling. A range of hills in the distance must be captured in one brush stroke' – my own sentiments entirely!

A Yorkshire Lane Angus Rands

Angus was the first person I went to when I decided, in my fifties, I wanted to paint in watercolours. I had a week's course with him in the tiny village of Kettlewell – and rather like one's first 'love affair' it had a great effect on my subsequent approach to the subject. I feel I owe Angus a great deal. During a 'demo' he would stand in front of his easel, rather like a fencer and work with lightning speed.

Freshness and spontaneity were his main aims in painting, always working in the open air in all weathers, using a large stone hung by string to stop his easel from blowing away! You can see from this example, his work had enormous vitality.

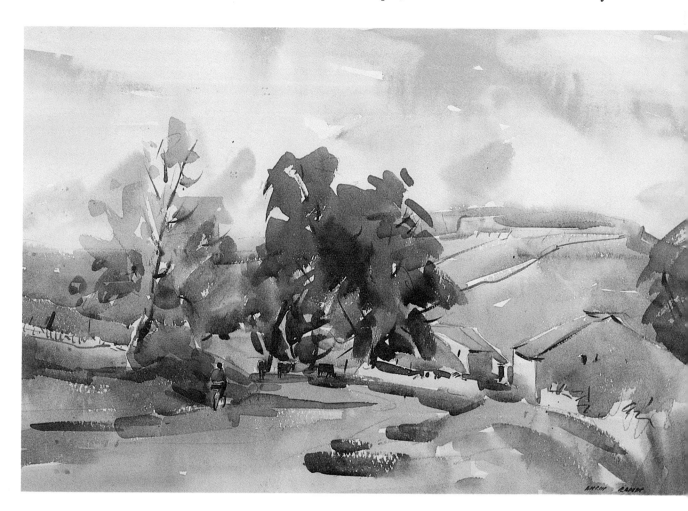

Mnandi Beach Douglas Treasure

This is a painting by a celebrated South African artist which I saw in the 1985 RI exhibition and I was struck immediately by its simplicity and purity. The scene has been beautifully and carefully resolved. Not a single stroke has been wasted. The handling of the foreground pools is masterly. The centre of interest is of course the two boats, achieved by making them the area of maximum contrast and counterchanging them against the light beach beyond. The whole painting is a result of great accuracy and forethought, together with a lightness and freshness of application.

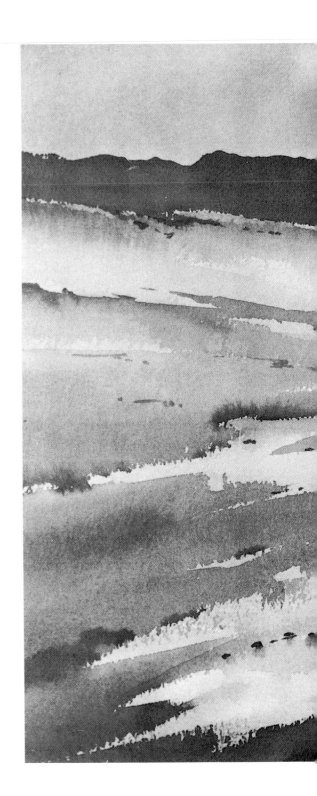

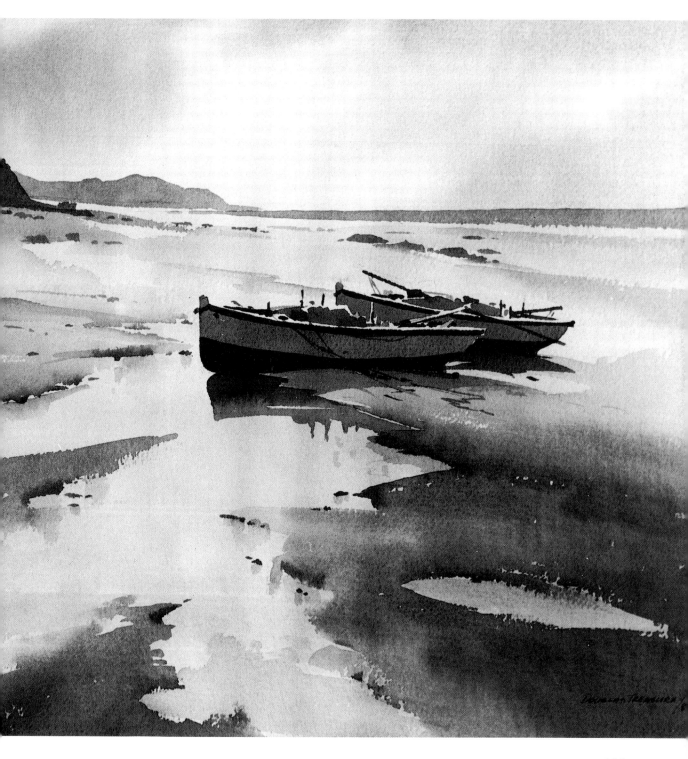

The Dyke in Winter Edward Seago

Without any doubt at all this man is my own personal hero – I had long coveted a 'Seago' and when I finally bought it from the Richard Green Gallery in London it cost three times as much as the rest of my collection put together – but well worth it! Seago had an amazing following during his life-time. Whenever he held an exhibition anywhere in the world, queues would form long before the opening with usually a sell-out in the first few hours.

I love the drama and contrast of this painting. It is dominated by the threatening clouds with a small area of clear sky. Against this pure yellow are placed the black silhouette of the tree and gate. The snow in deep shadow is punctuated by the contrasting black and yellow of the dyke. This didn't happen by accident – it was well thought out beforehand.

Seago was a master of economy of brush strokes – every one counted and not a single one was wasted – a philosophy which echoes the main message of this book.

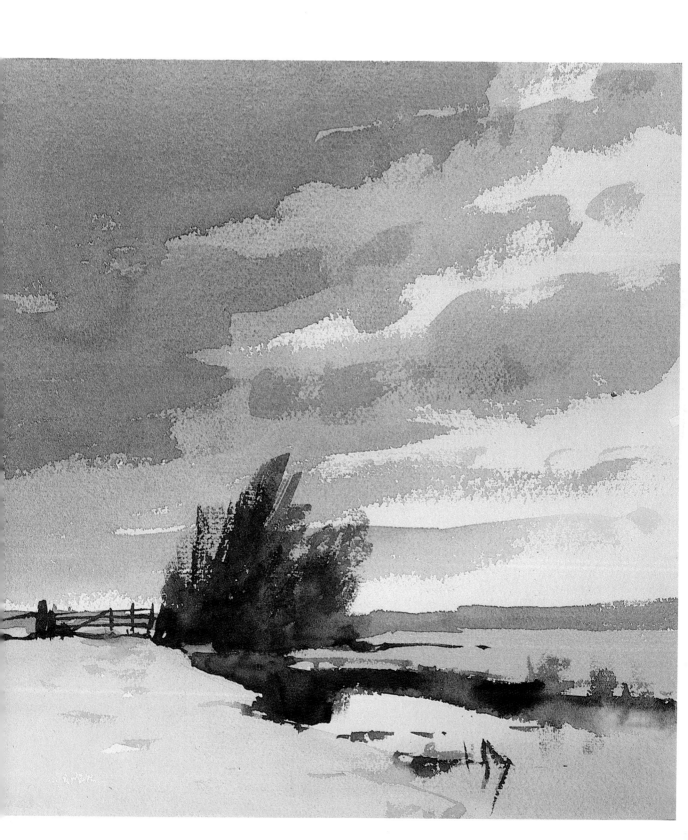

index